foundation course

life drawing

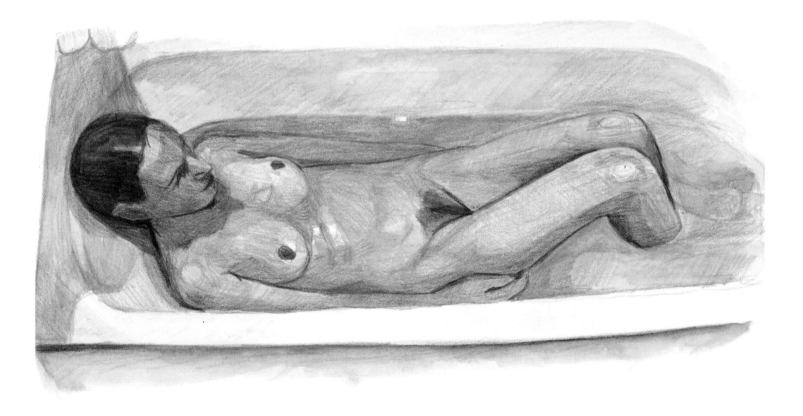

foundation course

life drawing

Ian Rowlands

CASSELL
ILLUSTRATED

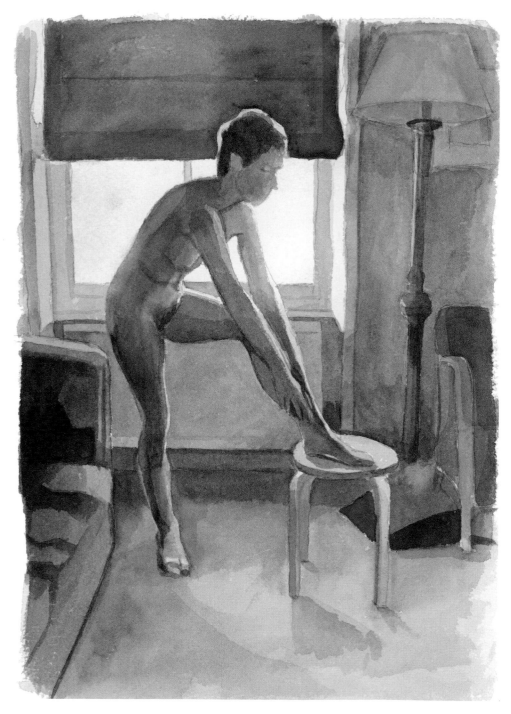

First published in Great Britain in 2005 by Cassell Illustrated
a division of Octopus Publishing Group Ltd.
2–4 Heron Quays, London E14 4JP

Text and design © 2005 Octopus Publishing Group Ltd.
Illustrations © 2005 Ian Rowlands except those specified on
page 144.

Series development, editorial, design and layout by
Essential Works Ltd.

Distributed in the United States of America by
Sterling Publishing Co., Inc.,
387 Park Avenue South, New York, NY 10016-8810

A CIP catalogue record for this book is available from
the British Library.

ISBN 1 84403 391 0

EAN 9781844033911

Printed in China

Contents

Introduction 6
 A history of life drawing 7
 Working at home 12

Tools and materials 14
 Pencils and graphite 16
 Charcoal 20
 Chalks and conté 22
 Coloured crayons 24
 Pastels 26
 Pens 28
 Inks 30
 Watercolour 32
 Gouache 34
 Papers 36
 Other equipment 38
 Recipes 42

The human form 44
 The skeleton 46
 The skull 48
 Muscles 50
 Proportion 52
 Form 54

Techniques 56
 Line drawing 58
 Shading and erasing 62
 Introducing colour 66

Making drawings 70
 Coordinating hand and eye 72
 Composition 74
 Context 76

Space 78
Perspective 80
Foreshortening 82
Measurement 84
Tone 88
Drawing the head and face 90
Drawing the body 94
Drawing the limbs 96
Drawing hands and feet 98
Using light 100
Balance 102
Movement 104
Storing and protecting your work 106

Masterclasses 108
Foreshortening: Figure on a Bed 110
Preparing for oils: A Head
 in Watercolours 114
Using negative shapes:
 Two Figures 118
Working with watercolour:
 Against the Light 122
The body as landscape:
 Reclining Nude 126
Harnessing space: Figure
 and Pattern 130
Light and colour: Christelle
 in the Spring 134

Glossary 138
Index 141
Acknowledgments
and Picture credits 144

Introduction

Since prehistoric times, humankind has aspired to create drawings that represent the human figure, first of all on cave walls, later on ornamental objects, and eventually on paper. This urge is still with us today, and this book aims to explore the world of life drawing from a highly practical point of view. One of the most common problems experienced by beginners is an inability to 'see' their subject with an artist's eye. By following the advice in this book, you will learn skills and working methods that will heighten your sense of seeing, so that you no longer rely on preconceived notions of what the body should look like.

Consider the vast array of drawing materials and surfaces available to the artist and you can see there is a very wide scope for experimenting and probing this fascinating subject. The first section is a thorough and succinct guide to the different types of tools and materials available, offering sound advice on their necessity and usage.

Next we examine the most important attributes of the human form for the artist, learning about the body's structures and shapes. The following section looks at the most fundamental techniques used to depict the figure, the use of line, shading and colour, using in-depth, easy-to-follow captions to guide you through to proficiency.

The next chapter explores in detail the process of creating a drawing, from composing and lighting the scene before you, to judging proportions and perspective, and dealing with the artistic challenges offered by different parts of the body.

With the basics in place, you will be ready to enter the Masterclasses, which show you step-by-step how a number of drawings on different themes were composed, developed and completed, from initial sketches to coloured and finished work. Each drawing presents its own problems and rewards.

Drawing from the figure is a real privilege – no other subject is so engaging while at the same time imparting such knowledge of form, proportion and space. Confronting the figure is inspirational, and even if you move away from working from the figure, time spent with the model will provide you with solutions to problems you may encounter in your work at a later stage. So when you are ready, take up your charcoal and enjoy!

A history of life drawing

Making life drawings is an important element in an artist's development, and may be a means unto itself, a journey to explore line, form and balance, or a study towards something greater, such as a painting. Representing the figure is, however, as natural an urge as talking or writing.

Early images

The prehistoric cave drawings of Lascaux in France and Altamira in Spain, which depict people and animals, are evidence of our innate desire to draw or record. Although their locations are distant from one another, the images have many similarities, and may symbolize a successful hunt or act as a good luck totem. Similar works exist in Turkey and in the remains of prehistoric settlements in the Sahara. During the first civilizations, in Egypt and Mesopotamia, more sophisticated paintings and sculptures were crafted. The work was now made by artisans whose prime purpose was to embellish objects. Egyptian tomb paintings and brush drawings on pot shards depicted people performing everyday tasks, such as gathering and pressing grapes. In contrast to the paintings, Egyptian sculptures are particularly realistic. The early Greeks carried on the practice of wall paintings during the Minoan and Mycenaean civilizations.

The Greeks

During the Greek archaic period we see more sensuous depictions of the body, often naked, particularly on amphora vases. But it is the Greek classical period that sees the celebration of the

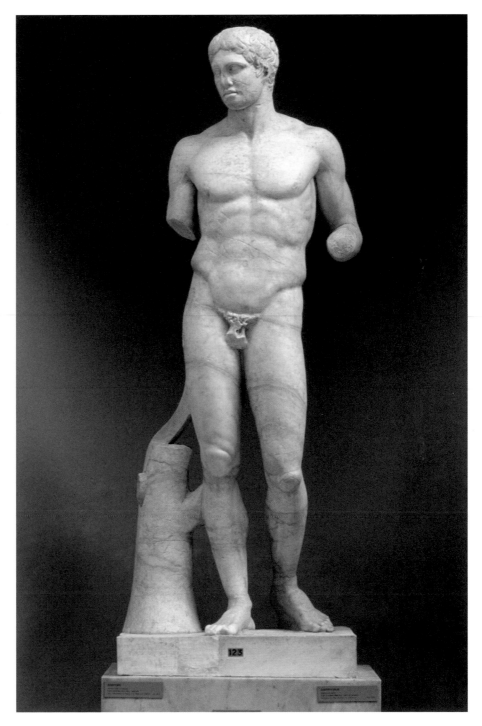

Greek classical sculptors had a remarkable grasp of the complexities of the human form. Polykleitos created the Doryphoros (c. 450 B.C.E.) in order to support his theories on the relative proportions of the parts of the body. The figure has adopted a natural 'chiastic' pose, meaning that weight of the body is resting on one foot.

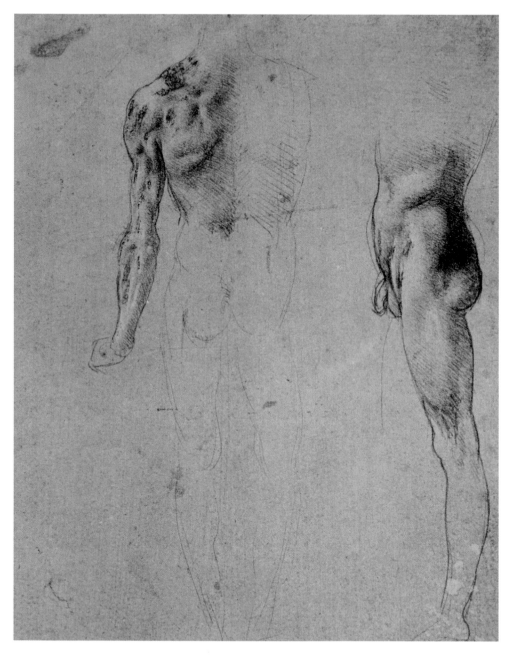

body in all its glory, in sculpture. The Venus de Milo and the Belvedere Torso are two famous examples. So accurate are these depictions in terms of anatomy, form, proportion and balance, that it is difficult to imagine that their creators did not study the body via drawings. The Greek classical influence eventually passed into Roman hands and was later buried under Byzantine and Gothic art, where the style is generally naïve.

The Renaissance

From the 1300s to the 1600s the Renaissance saw a return to Greek classicism, and its primary subject was the elegance of the human body. This period sees an incredible flowering of talent, aided by patronage and the studio and apprentice system, in which key figures, influential draughtsmen and visionaries passed on their knowledge to others.

The rise of naturalism meant that artists were required train their eye by making studies, as is evident in the drawings and notebooks of Da Vinci (1452-1519) , whose desire to understand the human form overflows on page upon page of exquisitely drawn anatomical studies. Da Vinci was a technical innovator who used a variety of media, especially pen and ink, and he was one of the first artists to use red chalk. Michelangelo (1475-1564) produced even greater realization of form, showing the body at rest and in motion with great forcefulness, leaving no doubt as to the solidity of his figures. His contemporary Raphael (1483-1520) made many sublimely graceful, flowing, but totally convincing drawings of the body.

By now the role of the artist was elevated to high status. Titian (c. 1488-1576) was appointed as painter to the state and associated with monarchs, princes and popes. His depiction of the body and his methods influenced painters up to the 1900s. Outside Italy a number of painters made great drawings of the body, particularly Dürer (1471-1528), who studied the body in a similar way to Da Vinci. He was a master of line and used hatching to give a three-dimensional quality to the figure.

Drawing of a man's shoulder and lower body *(c. 1480–1519) is a fine example of Da Vinci's wide-ranging technical innovation with various media. He was also adept at working in pen and ink, chalk and silverpoint. In his many notebooks, his desire to understand the human form is apparent on page after page of the most exquisitely drawn anatomical studies.*

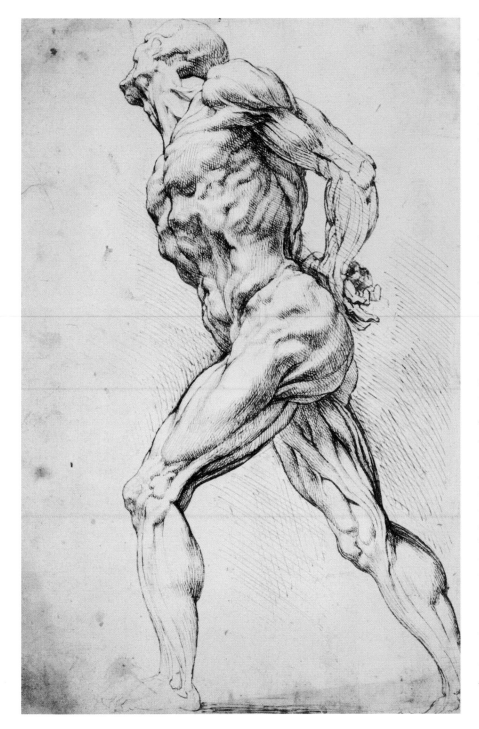

1600-1800

The period following the Renaissance was fertile and Titian's influence was particularly felt in the work of Rubens (1577-1640). He saw the value in making copies of great paintings, particularly those of the greatest Italian draughtsmen of the previous century. He was particularly drawn to masters of composition: Da Vinci, Michelangelo and Raphael. Rubens used drawing to aid the composition of paintings that would mainly be carried out by his team of apprentices. These were usually made in pen and ink, with separate drawings of anatomical details in chalk, often in several colours. These were kept in the studio as a resource for his assistants. Like many great artists, he could invent figures from memory, and all were used to great effect.

Rembrandt's vision of the body was less idealized and more intimate. For him a drawing could stand alone and have the nobility of a painting or it could be a testing ground for ideas. His preferred medium was reed pen and ink; his style could be free and vigorous. His mastery of drawing was acknowledged in his lifetime.

Towards Impressionism

The 1800s was another period of great change in painting and drawing. The French Académies continued to instill the importance of superior drawing skills but their authority was increasingly challenged. The French artist Ingres (1780-1867) studied form and proportion in drawings that he would refer to while painting. He was a pioneer of the pencil, which gave him more control. In a group of nude studies for *Golden Age* and *Turkish Bath* the draughtsmanship and voluptuous quality

Rubens used pen and ink with a sense of freedom, as is apparent in Anatomical study of a male *(c. 1577–1640). His extensive knowledge of the body allowed him to invent figures from memory. Such knowledge was gained from intense study of the body through drawing. His drawings were kept in the studio as a resource for his apprentices.*

of line is astounding. The French Académie spawned the talents of Manet (1832-1883), Degas (1834-1917), Seurat (1859-1891) and Pissaro (1830-1903) who, along with Renoir (1841-1919), became key figures in Impressionism and who drew inspiration from the body.

Drawing was central to Degas' art and it is possible to see the impact of his early copies after artists such as Raphael; in a sense he reasserted the importance of draughtsmanship. A line can be traced back from Degas to Ingres, whom he greatly admired. In a sense the Impressionists were rebelling not against the great art of the past but against the establishment who couldn't move

forward. Attitudes towards drawing were changing and new ideas were being championed by a few enlightened individuals, such as Horace Lecoq de Boisbaudran. He advocated that students should analyse forms carefully then memorize them. Under his tuition models were posed more naturally, often in the open air. He also encouraged students to memorize scenes from everyday life. His system was adopted by many artists, including Rodin (1840-1917), and must surely have filtered down to the likes of Manet and Degas.

Rodin's methods were totally unique. He filled his studio with models, encouraged them to move, and created the most incredible outline drawings.

We can assume that his study of memorizing form had blossomed and a sculptor's heightened sense of balance resonates in these drawings.

The works of the Post-Impressionists would influence a great deal of art in the 1900s. The emotional outpourings of Van Gogh (1853-1890) would influence Expressionism and the search for geometry in nature by Cézanne (1839-1906) would plant the seeds for early Cubism.

The 1900s

As the twentieth century got underway Bonnard (1867-1947) drew figures in intimate surroundings with great sensitivity. He drew incessantly, from all aspects of his life. His wife Marthe was obsessive about bathing, and this activity is well documented in a series of wonderful drawings and paintings. He would draw on any scrap of paper using a soft pencil so short that it looked like his fingers were making the marks. His nudes have an intimate, pictorial quality that seems to take them beyond the ordinary life drawing. These drawings, and his memory, allowed him to fix transitory moments in time in a series of wonderful paintings.

Among others, Schiele (1890-1918) made use of the nervous, sinuous line to produce nudes often disturbing in their honesty. Matisse (1869-1954) was a master of the seductive line and the decorative, responding strongly to the presence of the model. Picasso (1881-1973) could work in many genres but his drawings always seem to have a disturbing edge to them, particularly the hundred magnificent and varied approaches of the Vollard suite of etchings produced in the 1930s.

The British artist Augustus John (1878-1961) was praised for his exceptional draughtsmanship

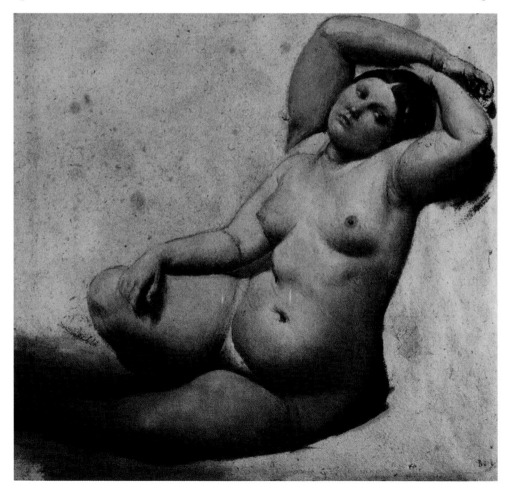

Ingres studied form and proportion in his drawings of the human figure, such as Study for the Turkish bath *(c. 1859), to help him in his painting. His studies were a proving ground for his ideas and gave him more control when dealing with the complexities of group compositions such as* Golden Age *and* Turkish Bath.

and his drawings are arguably more successful than his paintings. As students he and his contemporaries at the Slade were encouraged to study the works of the Old Masters at the British Museum and National Gallery. Perhaps for this reason his work connects more to the Renaissance than the 1900s. In the mid- to late 1900s abstraction dominated artistic output, but a few individuals bucked the trend and worked from the figure. R. B. Kitaj (1932–) penned the phrase the 'School of London' when referring to the major British figurative painters, such as Lucian Freud (1922–), Euan Uglow (1932–2000) and David Hockney (1937–). All of these, although working in different ways, have drawn the nude. They have influenced a new generation of artists.

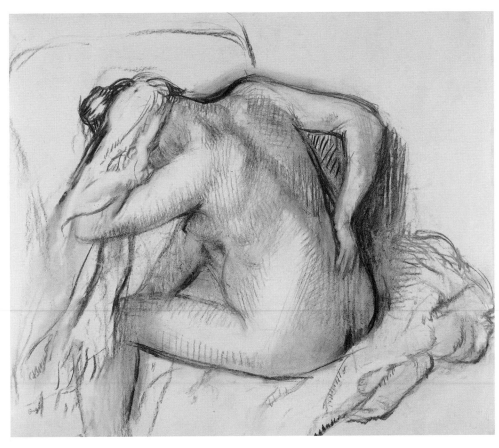

Degas' drawings have something of the sensibility of the masters of the Renaissance, as seen in After the bath, woman drying her hair *(right, c. 1895) and the dense pastel work* After the bath, woman drying herself *(below, c. 1886). He drew inspiration from the body in natural activities. In 1886 he exhibited a suite of pastel drawings of bathing women to critical acclaim. His use of light and the sense of volume that these drawings evoked were remarkable; they are rightly regarded as masterpieces.*

Academies and ateliers

The Renaissance artists learned their craft as apprentices in the studios of practising artists. Later generations gained their knowledge through the academies and ateliers of the 1700s and 1800s. In Britain the Royal Academy split into two in the 1800s, forming The Academy of Living Models and the Plaister Academy. To gain access to the former, students at the Plaister Academy had to endure months or years of working slavishly from plaster casts. Once in the life class, they were supervised by a series of visitors, often the most skilled draughtsmen of their day, such as Dyce and Mulready, Cope, Millais and Leighton.

During the 1800s the French Académie des Beaux-Arts, and its offshoot the École des Beaux-Arts, ran a very rigorous programme of study, moving from a focus on anatomical parts to drawing posed models with the emphasis on seeing the form as a whole.

In Britain women were not allowed to attend life class alongside men and, when the system finally relented towards the end of the 1800s, they were told to maintain decorum when entering the life room. In tandem with the academies a small number of private ateliers that were open to all existed in London; one of these, Heatherleys, is still operating.

Today there are no such constraints and it is possible to have access to a model and tuition both day and night, without breaking the bank.

Working at home

The life class offers many advantages. Private tuition and models are expensive whereas in a class the cost is spread. A class should also provide a decent amount of space, good light and heat. You will also find that the camaraderie and encouragement of your fellow students is often almost as beneficial as the input from your tutor. However, between classes it is likely that you will wish to work at home if progress is to be made.

Daylight bulb

Normal tungsten bulbs provide a comfortable ambient light to work in but if you are working in colour it is helpful to illuminate your work using daylight bulbs, which are formed from blue glass and provide a cost-effective working light comparable to daylight. Low-energy daylight bulbs that fit both anglepoise and clip-on lamps become less hot and have a decent lifespan. Daylight bulbs are most effective when aimed at the drawing rather than the subject, as the combination of two temperatures of light on the model is difficult to work with.

The domestic environment may seem less sterile and formal than the life class, which can lead to drawings with a strong contextual content.

Space

Lack of space is often a problem when working at home, and this is particularly apparent when determining the distance between artist and model. Measuring the model at close quarters is difficult, and sight-sized drawings would be huge. Furthermore, distortions such as foreshortening become more pronounced when the model is close, so you may need to consider working in the one of the larger rooms in your home sometimes. If you have a reasonably sized spare room, it can be quite easily be converted to a studio space. When drawing or painting the two most valuable commodities are space and light, so a home studio should be flexible in order to maximize the former.

Lighting

Daylight is the best light to work in, but it is at times too fierce. And it is often at night when there is the only opportunity to work. So your home studio will need a combination of adjustable natural and artificial lighting.

Heating

The comfort of an unclothed model is of the utmost importance. Central heating should provide a comfortable ambient heat, but should an additional source be required there are a number of choices. However, safety must be borne in mind, especially around art materials.

Storage

In a small home studio, storage is a major issue. Portable solutions that allow tools and materials to be moved around but stored efficiently are ideal. It is important to be able to locate particular items quickly, otherwise you tend to make a mess looking for them, so labels are helpful.

Props

If you are not using your home furniture in your studio, some improvisation will be required. The trestle table makes the perfect support for a folding mattress for reclining poses, as do stacking crates. Chairs should be comfortable, offering the decent back support and without sharp surfaces. Drapes can be used to add colour to backgrounds and disguise the utilitarian nature of some of your props.

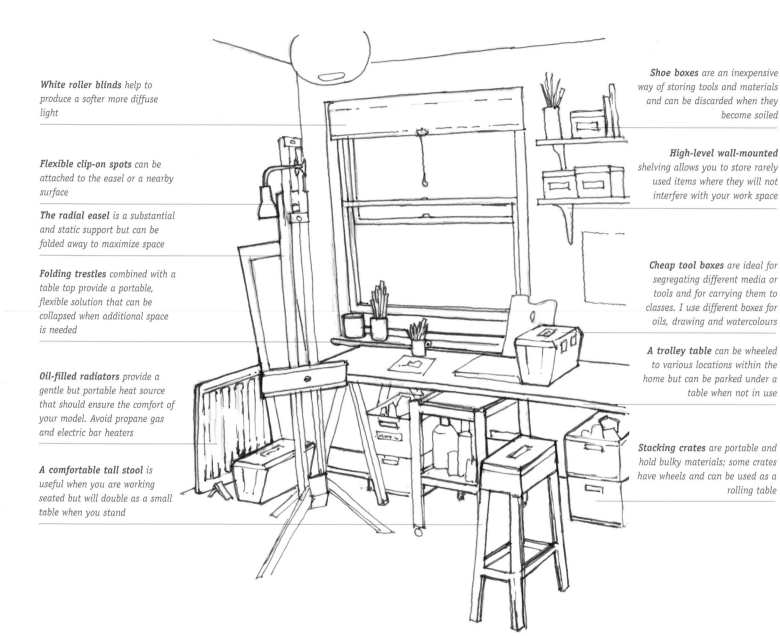

White roller blinds help to produce a softer more diffuse light

Flexible clip-on spots can be attached to the easel or a nearby surface

The radial easel is a substantial and static support but can be folded away to maximize space

Folding trestles combined with a table top provide a portable, flexible solution that can be collapsed when additional space is needed

Oil-filled radiators provide a gentle but portable heat source that should ensure the comfort of your model. Avoid propane gas and electric bar heaters

A comfortable tall stool is useful when you are working seated but will double as a small table when you stand

Shoe boxes are an inexpensive way of storing tools and materials and can be discarded when they become soiled

High-level wall-mounted shelving allows you to store rarely used items where they will not interfere with your work space

Cheap tool boxes are ideal for segregating different media or tools and for carrying them to classes. I use different boxes for oils, drawing and watercolours

A trolley table can be wheeled to various locations within the home but can be parked under a table when not in use

Stacking crates are portable and hold bulky materials; some crates have wheels and can be used as a rolling table

Home studio equipment

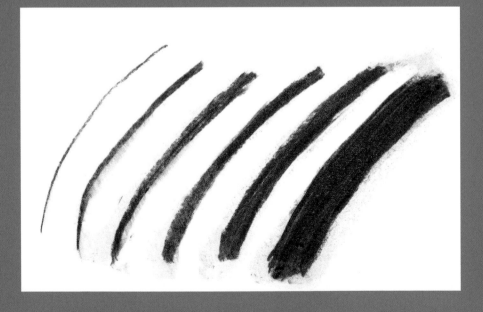

Tools and materials

Pencils and graphite

Naturally occurring graphite is composed almost entirely of carbon and has been formed, much like coal, by the action of high pressure on prehistoric forests beneath the Earth's surface. While coal is formed by the action of pressure alone, volcanic heat is also a factor in the formation of graphite, resulting in a material that is metallic in appearance and soft enough to make a dense mark. England's Lake District is a prime source of solid graphite, which has been mined there since the 1500s. The best grade, however, comes from Sri Lanka, where the percentage of carbon in the graphite is high.

Pencil history

The first pencils were manufactured in the 1600s, but it was not until 1794 that the first modern pencil, a highly portable form of graphite, was made by the French mechanical genius Nicolas-Jacques Conté (1755–1805). He found that by adding clay to graphite and firing the mixture at high temperature, he could create a harder, more robust material. By varying the percentage of clay used in the mix, he was able to produce different degrees of hardness and softness.

The graphite pencil is almost certainly the most commonly used drawing implement used by artists, for many good reasons. Pencils require no fixing to make their marks permanent, they are very clean and portable, and their different degrees of softness allow the creation of a vast spectrum of tones.

Pencil is primarily a linear drawing medium. If sharpened, it can give very crisp, precise lines; if used with a blunt tip, a soft, sensitive line will result. To sharpen a pencil I prefer to use a knife to cut a long exposed lead, finishing with sandpaper to give a sharp point.

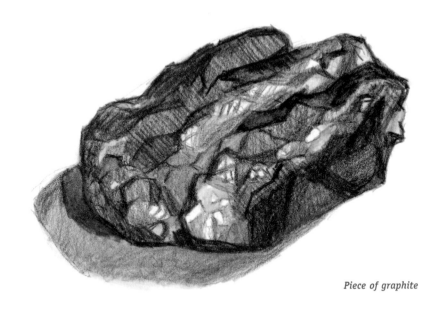

Piece of graphite

Grades of lead from soft to hard

The tones shown below were created by pencils ranging from 8B to 2H, from left to right. The B suffix indicates the soft nature of the pencil; the H suffix indicates hardness. Although it is possible to obtain grades harder than 2H, you may think the mark created is too faint. In practice, you may find that you get more appropriate tonal shift not by using every grade but perhaps by selecting only odd or even numbers.

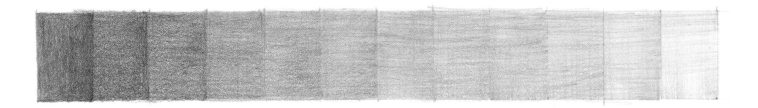

Clutch pencil

Clutch pencils grip the lead, which can be up to 5mm in diameter, in jaws that can be opened to allow the lead to drop down. Propelling pencils advance the lead mechanically. Their leads require no sharpening, as they are 0.5–1mm in diameter. In both types, when the lead shortens, all you need to do is advance more; the lead can also be withdrawn for safekeeping.

Pencil sharpened with sharpener

Pencil sharpeners offer a convenient and safe way of creating a sharp point. However, although sharpeners are efficient at first, the blade soon becomes blunt, leading to breakage of the lead.

Pencil sharpened with knife

Pencils are best sharpened with a sharp knife. A scalpel, or better still a penknife, will do the job. Sharpening by knife gives a long lead that can be allowed to blunt or may be further sharpened using emery board.

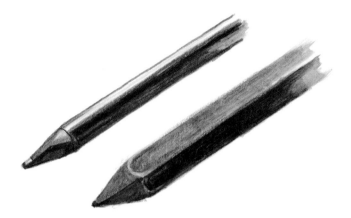

Graphite sticks

Graphite sticks or crayons, which are also available in various grades, shapes and sizes, expand the range of mark-making possibilities and are well suited to tonal rendering of the subject. Used on their edge, a smooth layer of tone can be quickly laid down.

Graphite powder

Powdered graphite (left) can be rubbed into the paper to provide areas of smooth tone. It is useful for tonal reductive drawings in pencil.

Water-soluble graphite

This is a recent addition to the range of graphites and allows monochromatic line-and-wash drawings to be made using a fairly clean material. It is possible to erase areas of tone made using this graphite, once they are dry. This method is particularly useful for adding strong points of light to the drawing.

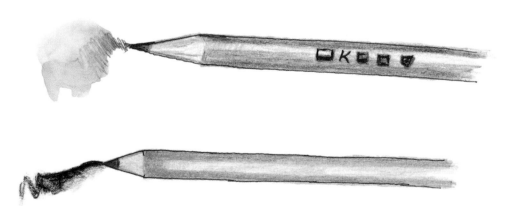

Wolff's carbon pencils

Not made from graphite, this popular type of pencil produces a rich, velvety, black line well suited to linear and tonal work.

Silverpoint

Long before the invention of the pencil, the early Renaissance masters used a technique called silverpoint. This allowed them to draw very precisely, creating entire drawings or adding local detail to chalk drawings. Silverpoint involves using a metal wire, usually silver, to draw on to a paper coated with a pigment solution. The wire reacts with and is abraded by the paper, leaving a permanent mark. If you can't find prepared paper, you can easily prepare your own (see **Recipes**, *pp.42–43*).

Old master silverpoint drawings were often made on coloured grounds (coated surfaces). For example, the German Hans Holbein (c.1497–1543) combined silverpoint and coloured chalks over a pink ground for highly finished portraits; the pink was no doubt a useful approximation for flesh tones. And the Italian Leonardo Da Vinci (1452–1519) sometimes combined silverpoint with chalk highlights on dark pink or lilac grounds, modelling forms to dramatic effect.

Silverpoint tool wooden handle
This silverpoint tool (above) has a 1mm silver wire tip permanently fixed into a comfortable holder.

Silverpoint tool adjustable metal holder
Adjustable metal holders (below) that allow you to select different widths of wire can be purchased. Most are double-ended, so you can use two widths of wire if desired. You could also use a clutch pencil as a holder.

Silverpoint image
The marks made using silverpoint are initially similar to those of graphite, but they tarnish over time to form silver sulphide, which has a pleasing silver-brown colour. You can use silverpoint to produce line and tone; for tone you will need to use hatching. Since your marks will not be erasable, it is a good idea to prepare your

drawing well and also to become confident in drawing before trying silverpoint. For these two silverpoint drawings (right) I prepared pink grounds. Working over colour allows you to add white chalk highlights sparingly to expand the tonal range. The second drawing had more red pigment in its coating to allow an increased range.

Charcoal

After the pencil, the most widely used drawing material is charcoal. It is also the most basic drawing material and one of the oldest. Natural charcoal is available as small, peeled, round twigs and as sticks split from larger branches. Its marks are easily erasable on most papers, allowing changes to be made at any point and enabling the drawing to be kept fluid. Large charcoal sticks can be used on their sides to cover large areas of the paper with dense tones, while sharpened splints are useful for detail.

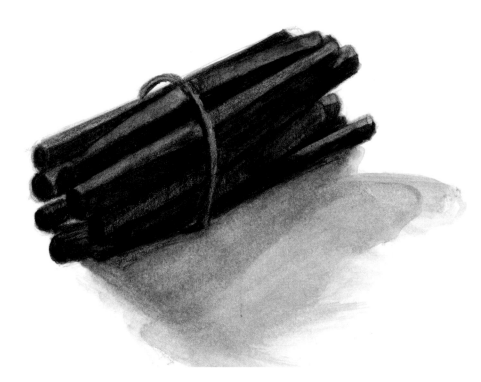

Willow charcoal bunch

Willow charcoal

Charcoal is made by firing wood, usually willow or vine, at a high temperature in an airtight container. During this process, air is excluded so that the wood can form carbon without fully undergoing combustion. Unlike vine, which often goes out of supply for long periods, willow is harvested annually during the winter months from a sustainable crop and is therefore usually easy to obtain.

It is not possible to sharpen small round sticks of willow charcoal by sanding because they have a soft core that powders away immediately. However, it is possible to use the sharp edge formed by snapping the sticks, or to cut them at an oblique angle with a sharp knife; this edge will, however, wear down quickly.

Compressed charcoal

Compressed charcoal is an effective material for tonal reductive drawings, which are made by creating a uniform area of tone on the paper and then erasing certain areas or adding further tone to others. To start, cover a sheet of paper with compressed charcoal and rub it in with a tissue to create a grey ground. You can then draw into this with an eraser to depict areas of highlight, and add charcoal marks to represent shadow. Subtle use of a kneadable eraser will enable you to create intermediate tones, while a plastic eraser will cleanly remove more charcoal to give bright highlights. If you want to achieve dramatic hard-edged effects, try using erasing or shading templates.

Willow charcoal widths
Willow charcoal is sold as round twigs in various widths from thin to extra thick. The widest willow charcoal available is known as a tree stick. Greater width indicates greater age and, in general, the wider the stick, the harder the charcoal.

Compressed charcoal
Compressed charcoal is not made from wood but consists of black pigment mixed with a binder and formed into a stick. It produces a deep, velvet black that is more intense than natural charcoal.

Oil charcoal soaking in jar
Charcoal can be made more resilient and dense by soaking it in linseed or poppy oil for about 24 hours, until the oil has been fully absorbed. Oil makes charcoal less prone to breakage, but the sticks must be stored in cling film or tin foil to prevent drying. For this reason oil charcoal sticks have a relatively short shelf life.

Oil charcoal mark
Oil charcoal, as it is known, produces dense lines that require no fixing but cannot be erased. Because of the slightly oily nature of this substance, it is advisable to work on gelatine-sized watercolour paper or else to prime some cartridge paper using acrylic primer.

Charcoal pencil
Charcoal pencils offer the same grades of hardness and softness as the sticks, in wood-encased form. They offer greater control than other types of charcoal when adding detail to both charcoal and compressed-charcoal drawings. Charcoal pencils also allow you to make dense, black, tonal drawings on a small scale.

Chalks and conté

Taking a piece of rock and using it to create an image is the oldest, most basic form of drawing. In prehistoric times the earliest artists – cave dwellers – recorded their lives and naturally selected the materials that were close to hand, using them in a direct manner. Natural earth pigments such as red ochre, yellow ochre, burnt wood, manganese black and charcoal were rubbed on to cave walls. During the Renaissance, long before the invention of the pencil, rocks in various colours were used in a highly controlled manner, producing fine studies of the figure.

Sanguine, a natural earth with a high clay content, has a long and illustrious history in drawing. Artists as important as Raphael (1483–1520) and Da Vinci (1452–1519) exploited its qualities for their precise figure drawings, its red warmth contributing to the fleshy quality of the drawings. Sanguine's softness varies according to the percentage of clay it contains: the higher the clay content, the harder the material. Harder varieties are easier to sharpen and cut and are therefore better for detailed drawings. You can purchase sanguine from specialist suppliers, but it tends to be a soft pastel-like material. However, you can achieve a degree of detail if you break the rock into small splinters – dropping it on to a hard surface is as good a method as any.

Found materials

Any material that will make a mark is a potential drawing medium, be it a piece of chalk found on a beach or a fragment of rock. An Italian friend gave me some lumps of earth from his garden that had been fired in a kiln. The earth had initially been yellow and because the garden was near Sienna you could say that this earth was a form of burnt sienna. Often called chalks, such materials are in fact minerals, mostly soft forms of natural iron oxides (clays), ranging from yellows, through warm reds to deep violets. These iron oxides still form the basis of the most reliable artists' pigments in use today and are found in all prepared artists' colours from crayons to oil colours.

Modern equivalents

As an alternative to natural materials, you can use crayons or wood-encased pencils made from iron oxides – black and white pigments held together with a binder to form a chalky but resilient stick. The conté crayon comes as a stick or wood-encased pencil, both providing an effective and drawing medium with a similar appearance to the rocks. I sometimes use black and white chalks or crayons for portrait studies, working in tones either side of a mid-toned paper to achieve a sense of solidity. Working in black, sanguine and white over a warm mid-toned paper is also effective for portrait and figure studies, providing solidity through tone but also adding a degree of local colour.

Coloured rocks

Black, yellow, burnt sienna, lump sanguine and white are pictured here from left to right, forming a small selection of historic found materials that could easily be used for drawing. The yellow, sanguine and burnt sienna are of Italian origin, the black is from Germany and the white is from the Test valley in Britain. It is very likely that you could discover similar materials closer to home.

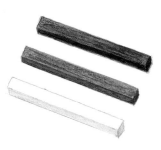

Sanguine mark
The mark made by sanguine is similar to that of soft pastel. Sanguine works well for a broad application but conté crayon and pencil are more suitable for precision.

Black mark
German black chalk makes a curiously grey, waxy mark that would benefit from a textured paper.

White mark
Natural so-called 'white' chalks in fact make a slightly off-white mark.

Conté crayons
The three classic colours of conté crayon are shown here: black, sanguine and white, which combine effectively for figure and portrait studies.

Conté line
The line produced by conté has a rich, velvety quality that is well suited to drawing the figure.

Conté tone
When conté is used on its edge you can very quickly cover large areas of the paper with a rich, continuous tone. At such times the papers texture exerts its influence.

Over-washing
When water is added to tone or line, a vibrant wash can be produced that could enliven the figure. Dry conté can then be worked into this wash.

Pencil forms
Besides conté crayon, some manufacturers also produce pencil forms in classic colours to give a more controllable line. Here we see bistre, sanguine and white.

Coloured crayons

Coloured crayons allow you to exploit colour in a clean, ordered way. They can be collected at the end of a session with the minimum of fuss. This medium offers a full spectrum of colour with few limitations and can encourage a level of ambition as high as that of some watercolour paintings. A coloured crayon is, after all, just another means of depositing pigment on a surface and in this respect it resembles a painting material.

Making coloured crayons

Coloured crayons are made by mixing pigment with inert filler such as chalk or kaolin, usually held together with a cellulose binder to form a resilient, portable stick. The sticks are immersed in hot wax to further increase their strength and impart smoother working characteristics. Toxic pigments such as cadmium and cobalt are avoided in favour of non-toxic, highly stable ones.

Types of crayons

Coloured crayons require patience. Their one major limitation, which is shared with watercolour, is the difficulty in making changes once the drawing is underway. A degree of planning and under drawing is therefore needed in the early stages of the work. A faint pencil drawing can serve well to indicate the areas that will remain white (the white of the paper) or pale. The best approach to shading is to build the image up gradually and to be patient.

Coloured crayons have, in the past, been seen as the poor relative in the family of art materials. Most books on materials advise caution in their use, but it is now evident that manufacturers are now addressing the issue of permanence.

Coloured crayons are available in water-soluble (below) and waterproof (left) varieties. Water-soluble crayons make softer marks that are easy to blend and can be altered by adding water after application. Waterproof pencils do not smudge and are particularly suitable for linear work.

The addition of water makes it possible to lay down a smooth continuous tone over which dry crayon can be used (bottom right).

Although many different hues are available in the various ranges, optical mixing by overlaying colours (top right) is necessary and gives the drawings an interesting glowing quality akin to pointillism.

This drawing began with a fleshy pink-coloured crayon applied to a hot-pressed watercolour paper, with a highlight reserved for the prominent area of the shoulder. This was then overwashed with water to create a continuous tone. Richer tones in Indian red and olive green were added, beginning the process of making the body appear three dimensional. Blue was added for a cool contrast in the back ground. The beauty of crayon is that you can work with it in an ordered way; the relatively compact nature of the kit; and that with just one box of 12 crayons, a brush and water, you may produce a highly finished work.

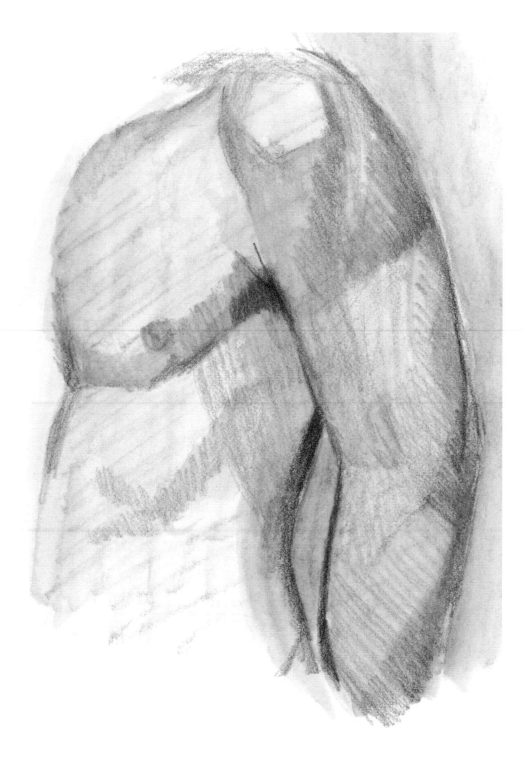

Pastels

Pastels are a useful addition to the artist's arsenal. Because they can be used dry without oils or solvents, with only a dozen or so colours you have the scope to make paint-like studies in front of the model. You can also make colour notes – visual guides to colour that can be used away from the life room. In short, they are a very useful, portable form of saturated colour.

The pigment in soft pastels is held together using just enough binder to form a stick that is capable of being handled yet remains soft enough to make a rich mark on the paper. It is this velvety quality that attracts many artists to the medium.

Pastel uses

Pastels may be used wet as well as dry, provided they are pulverized, and share many characteristics with gouache. Using a penknife you can scrape a small amount of pastel powder away from the stick and use a damp brush to mix it, before applying to the paper. You can also use pastels in the same way as Chinese stick ink, by rubbing the stick against a wet surface, such as an ink stone, to produce a liquid colour that you can mix or paint out just like gouache. Alternatively, you can use the pastel normally and over-wash it with a wet brush to create a base tone. Once this is dry, you can draw or paint on it using more specific hues.

Pastels combine well with other media, particularly gouache and watercolour. They may also be blended together when dry using a variety of implements, including paper stumps, to create mixtures and facilitate the rounding of forms. Transitional tones for rounding forms can also be achieved by using hatching to create optical mixtures. Indeed, pastels are so useful that pastellists tend to keep even the tiniest of fragments of broken pastel for use in areas of detail. The average pastel stick is approximately 1cm wide but it is possible to obtain wider sticks for large scale work. Various ranges of pastel pencils are also available, which are useful for picking out fine areas of detail.

Homemade pastels

If you find you enjoy working with pastels, it may be worth making your own. By making your own pastels you are using your own mixtures, as you would when working with paint and there is also an economic advantage; for a small outlay many sticks can be produced. To make the pastels a liquid binder is mixed with pigments and chalk to form a dough that is rolled into sticks before drying (see **Recipes**, *pp.42–43*).

Fixing and storage

Pastels should be only lightly fixed, in order to avoid compressing and dulling the pigments. They should then stored between layers of acid-free tissue paper or glassine paper.

Hatching

Hatching (above) and cross-hatching are two means of producing the optical mixtures that give pastel its vibrant quality.

Smudging

Another way of mixing pastel and creating the gradations so necessary when painting the figure is to smudge the drawn mark (above, centre). This can be done using the fingers or a paper stump.

Over-washing

Pastel can be over-washed with water to lay down areas of lighter, continuous tone that may be useful in the early stages of a drawing (above, right).

Pastel drawing

A combination of techniques have been used in this highly worked drawing (right). The main areas of the drawing were established in dry pastel before being over-washed with water. Once dry, pastel was used conventionally and pastel pencil was introduced to work on areas of detail.

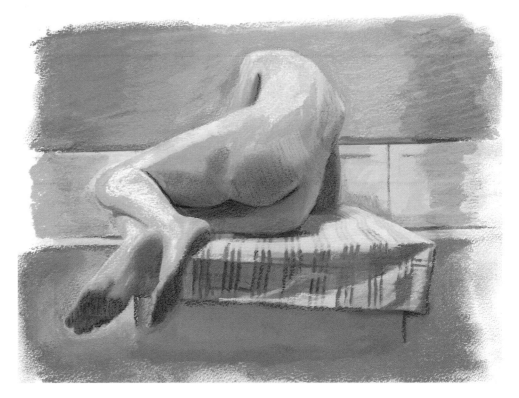

Pens

The use of a pen often produces flowing drawings. This is partly due to the liquid nature of ink, but there is also something about the way the nib glides across the paper that encourages fluid movement. And perhaps the knowledge that the pen's marks cannot be erased encourages artists to produce confident, flowing lines. You can purchase a huge variety of pens suited to a range of drawing styles.

Dip pens are inconvenient due to the need to recharge their nibs with ink and the associated danger of spillage. No wonder the first fountain pen, which fed ink to the nib through a refillable reservoir, was so lauded when the American Lewis E. Waterman (1837–1901) invented it in 1883. Steel-nibbed dip pens do, however, have one big advantage, which is the degree of flexibility they have in the nib, which is just not possible to obtain with fountain pens. Their flexibility allows variation in the width of the mark, which in turn helps to place weight in the line where needed. Dip pens can also be used with waterproof inks and are unique in this sense. Perhaps one day somebody will invent the ultimate drawing pen – a fountain pen with a flexible nib.

Reed or bamboo pens are types of dip pen first used by the ancient Egyptians and are still possible to purchase today. They can be used with waterproof inks but require even more frequent filling than conventional dip pens; fitting a reservoir can help slightly. These nibs feel less smooth on paper than metal nibs and their line is broader. Reed pens are best suited to larger-scale drawings.

Fibre-tip pens have been available for many years. Some time ago, their marks would begin fading after about 10 years, but you can now buy fibre-tip pens that use truly non-fading pigmented inks. Many come in a range from fine to brush type, allowing a sensitivity of line combined with continuous ink flow in one convenient package.

Art pens are a type of fountain pen specifically designed for drawing. They use only water-soluble inks and are refillable via either a cartridge or a piston-fill adaptor. The advantage of an art pen is the smooth, flowing feel of the steel nib, and the fact that it is refillable and relatively clean, making it perfect for life class. It does, however, share with other fountain pens a lack of flexibility in the nib.

The brush pen is a relative newcomer and a welcome one at that. It comes in two types, refillable and non-refillable, and with variable tip flexibility. The softer the tip, the lighter the pressure must be to avoid lines becoming too wide or over-fed with ink. The marks made by this type of pen may resemble those of Chinese brush painting and work well for large drawings.

Confident lines
Pen nibs glide easily over the paper's surface, encouraging you to draw smooth, flowing lines.

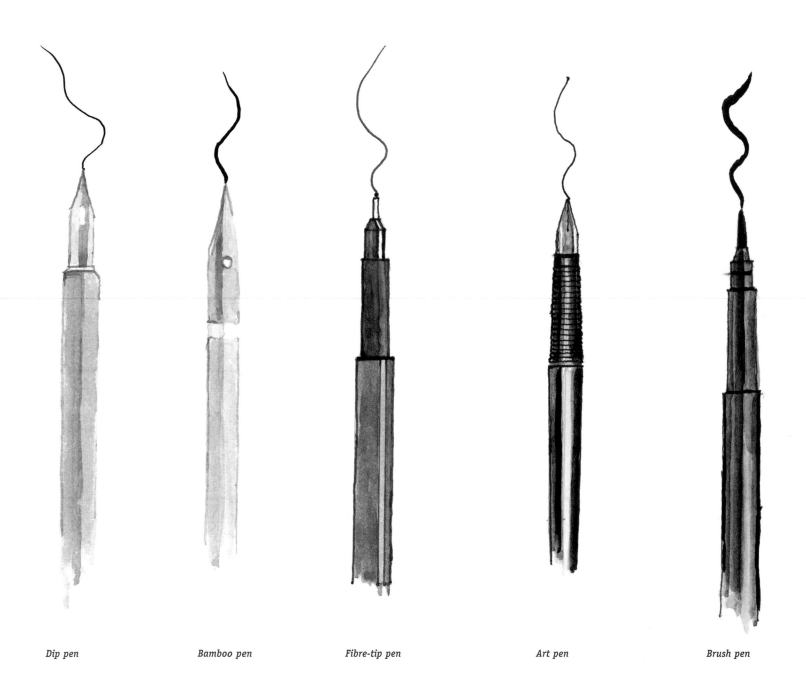

Dip pen

Bamboo pen

Fibre-tip pen

Art pen

Brush pen

Inks

Inks have a long and illustrious history in drawing, their use predating that of the pencil. Artists as important as Da Vinci, Rubens and Rembrandt made great use of pen and ink as a strong graphic medium for their studies of the human form. The liquid nature of ink can lend drawings a fluency that responds well to the curves of a figure. In common with paint, ink consists of a colouring agent mixed with a binder, which together create the ink's working qualities.

Binders

Inks may be soluble or insoluble in water and the function of the binder varies accordingly. In soluble inks the binder forms a film that adheres the pigment to the support while allowing the ink to be reworked when dry. In insoluble inks, the binder envelops the pigment particles, protecting them from mechanical damage and allowing them to be spread out. It also acts as an adhesive, glueing the pigment to the chosen paper. Traditional water-soluble binders are gums, particularly gum arabic. Water-soluble ink will dissolve after drying if simply wetted, allowing hard edges in a drawing to be softened. Shellac is the traditional binder for waterproof inks and makes the ink glossy. Waterproof ink can be overworked with ink or watercolour without fear of it shifting. Modern binders of waterproof ink are based on acrylic resins that, unlike shellac, also come in satin and matt finishes and will not crack once dry.

Colouring agents

Colouring agents for ink may be of mineral, vegetable or animal origin, with black and brown being predominant. Carbon makes the most permanent black inks, such as Chinese and Indian, and is basically the soot created by burning a variety of materials. Another black, iron gall, which does however change to brown, is made from the galls, or 'apples', of the oak tree. During the 1400s a brown ink was prepared from bistre; and during the 1700s genuine sepia ink had its heyday. You can purchase both sepia and iron gall ink from specialist suppliers, but if you want to try and make them yourself, see **Recipes**, *pp.42–43*. Coloured inks were derived from dyes that faded over time but the development of synthetic organic pigments with small particle size now provides us with highly permanent transparent inks.

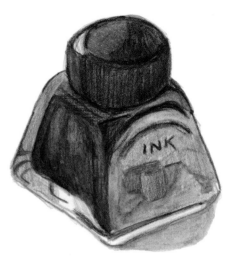

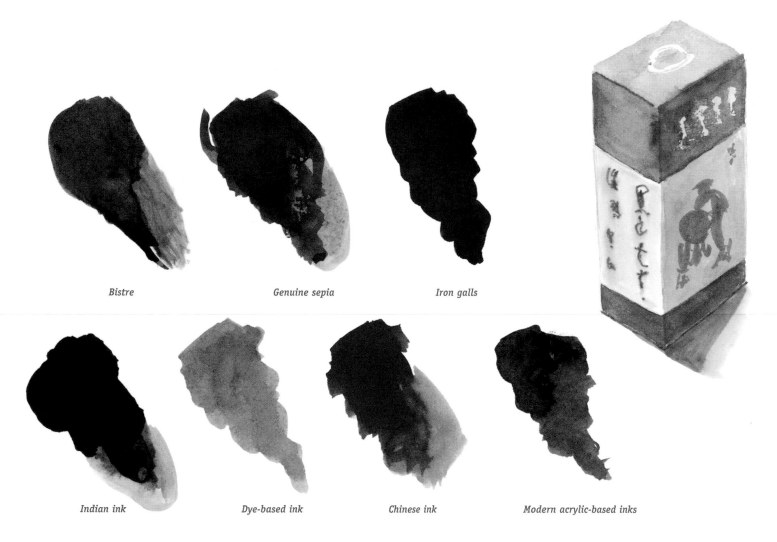

Bistre

Genuine sepia

Iron galls

Indian ink

Dye-based ink

Chinese ink

Modern acrylic-based inks

Bistre is made from beech tar and the name bistre is a corruption of the words. This ink is a rich, dark brown.

Genuine sepia is made from the ink sac of the cuttlefish and has a blackish-brown hue. Nearly all sepia inks sold today contain a mix of black and brown colourants.

Iron galls are rich in tannic acid, forming an ink that shifts in colour over time. It is initially blue-black and matures to a deep brown. Most iron-gall inks are bound in gum arabic and dry to form a water-soluble film.

Indian ink is a very intense black well suited to both robust and sensitive line. It may be diluted with water to create washes and dries to form a waterproof film.

Chinese ink is a dense black colour with a slightly brown undertone. It is well suited to brush application, especially oriental-type work. Chinese ink dries to form a water-soluble film.

Dye-based inks are available in traditional and extremely intense colours but are not generally lightfast,

and so work made using these inks should be kept out of strong light, preferably in a portfolio.

Modern acrylic-based inks are available in a wide range of permanent colours to suit the style of your picture. This brown shade, for example, would work well for traditional drawings.

Watercolour

It's not difficult to see why the use of watercolour is so widespread: no solvents or mediums other than water are required to release the colour and make it flow. The constituent parts of the colour are reasonably simple – pigment bound with a water-soluble gum – and yet the resulting paint film is as permanent as any other media, if not more so. The colour dries quickly due to the evaporation of water, making it the perfect medium to supplement pencil in a drawing or to be used as an expressive colourful medium in its own right.

Watercolour is characterized by its transparency. Its finely ground and dispersed pigment allows light to pass through it to reflect off the white of the paper, heightening the colour's brilliance. This effect can be lessened by some of the major colours, which may be fully or semi-opaque.

The transparent watercolour we enjoy today is a quintessentially British medium that enjoyed its golden age in the late 18th and early 19th centuries. Watercolour excelled at providing the painter with a means of making a wide variety of colour mixtures in a compact, portable package, and the same holds true today.

Colours for flesh

The best approach to colour is to keep matters simple, by favouring primaries. A crisp lemon yellow for its clean mixes, cadmium red, alizarin

Colourful shadows

With the model posed against the light, I wanted to record the wonderful radiance of colour in the shadows, and watercolour seemed the best medium. Time was short, so I restricted my palette to just a few colours: alizarin crimson, yellow ochre, ultramarine and black. At the time I felt that I had found the perfect range of colours, but today I rely on primaries that will provide the same colours but with more flexibility.

Pans and tubes

Watercolour comes in pan and tube formats. Pans offer fast access to the colour but tend to become contaminated when colours are being mixed, so it's important to clean their surfaces frequently. Pans also tend to dry out over time, making colour lift-off less intense; this can be offset by pre-soaking the pans (wetting the surface a few minutes before working). Tubed colours remain clean but have to be squeezed out on to a palette.

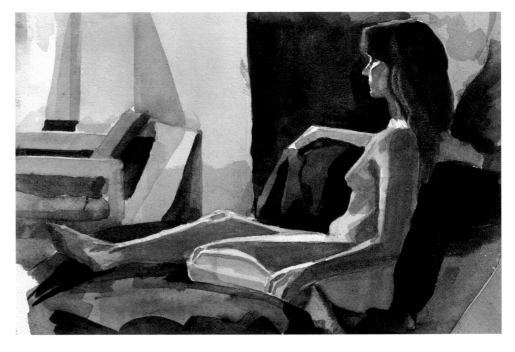

crimson, ultramarine blue, phthalocyanine blue or Prussian blue. These choices are based on having a cold yellow and a warm and cold variety of red and blue. By making the right choices and achieving the correct balance, it is possible to mix a wide variety of colours using a small range of core colours, they will also relate to each other better (see **Introducing colour**, *pp.66–69*).

Box of tricks

I bought this box when I was a student, for making studies for oil paintings, but I soon became hooked on watercolour. The beauty of this box is its portability; it has been around the world with me and I can just slip it into a pocket or bag. Within it is the colour potential to make both quick studies of the figure and highly resolved paintings. The inside of the lid and a fold-out palette-flap may be used for mixing colours.

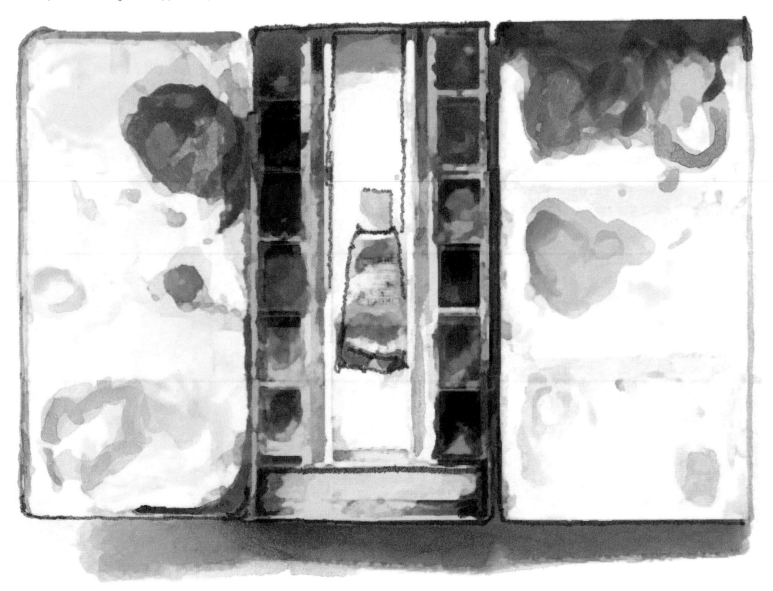

Gouache

Gouache is a versatile, water-based medium that can be used in a more direct way than watercolour, and the two may be used together. With watercolour you must leave areas of the painting untouched to serve as highlights; gouache, by contrast, allows constant reworking. It is an excellent medium for life-class studies because it can be used in a similar way to oils, allowing thin washes, opaque passages moving from dark to light, and ease of change – if the light changes during the course of a painting, gouache allows the painting to change with it.

While gouache shares many qualities with watercolour, transparency is watercolour's aim, whereas opacity is desirable with gouache; for this reason it is often referred to as body colour. How this opacity is achieved varies from brand to brand or even colour to colour within a brand.

Lemon yellow *Cadmium red light* *Ultramarine blue deep*

Ivory black with titanium white overlay

How gouache is made

Gouache usually has gum arabic as its binder, as does watercolour. Both media also use the same basic pigments, although gouache pigments may be modified. Opaque inert fillers, such as blanc fix or barium sulphate, are often added to render naturally transparent gouache pigments opaque. Manufacturers sometimes prefer to allow the pigments' true characteristics to come through instead. Cadmium red, for example, is naturally opaque because its pigment particles are large. But a cadmium red tone based on a modern organic pigment will have a smaller pigment particle size and will tend to be semi-transparent. By including both types in their ranges, manufacturers can offer us the maximum number of choices, whatever colour we desire.

Versatility

Although it is an opaque medium, gouache may be sufficiently thinned to resemble and often exceed watercolour in its colour saturation. With the figure in particular, I have found it possible to work with the same palette of colours as I would with oils, often restricting myself to just three colours. Like oil colour, gouache has a marvellous quality when you add a glaze by scumbling a pale, transparent colour over a darker underlayer. The glaze modifies the layer beneath yet allows its colour to show through, making subtle transitions of tone and colour possible. And when colour is applied more opaquely, highlights can ring out from the darkness, particularly useful when light is glinting on the body. It is a real pleasure to use such a direct, uncomplicated and highly portable medium whose experimental possibilities seem boundless.

Swift work

With the model adopting 30-minute poses, gouache proved the ideal medium for rapid work, with the assurance that changes could be made.

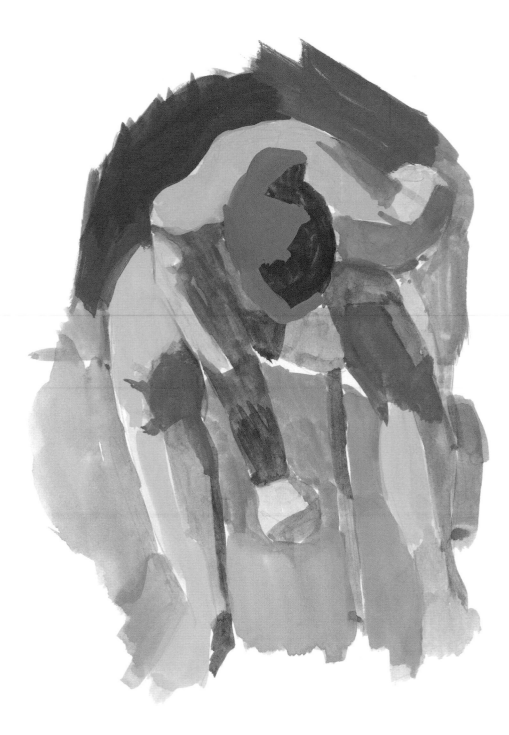

Papers

The role of paper in a drawing is as great as that of the drawing material itself and greatly influences the progress and the final appearance of the picture. Dry media, such as pencils and crayons, deposit their pigment within the web-like structure of the paper and work particularly well with textured papers. Wet media, such as ink and watercolours, deposit their pigment on the paper's surface and tend to work better with harder papers. Most drawing papers are made from wood pulp, as are many watercolour papers, but the finest papers are made from cotton rag. Whichever paper you choose, be sure to check that it is acid free (pH 7).

Cartridge paper is a good all-round surface that accepts pen, pencil, charcoal and crayon very well. Brilliant white papers increase the contrast of pencil and charcoal marks, while cream papers lower contrast and are sympathetic to sensitive work. Smooth papers are best for linear pencil drawing, while cartridge paper with a slight tooth traps the graphite particles and so is suited to shading.

Stretching paper
Any paper lighter in weight than 300gsm (grams per square metre) must be stretched (above) before being used with wet media, particularly if the intended technique will saturate the paper. Unstretched paper will cockle (form into permanent waves). First, thoroughly wet the paper under a cold tap and lay it out on a drawing board large enough to give a clear margin of 5cm (2in) at the edges. Wipe away excess water and allow the paper to rest for a few minutes. Use a sponge to wet the adhesive side of some gum strip and secure the edges of the paper, with an overlap of at least 1cm (½in). Allow the paper to dry, by which time it will be flat.

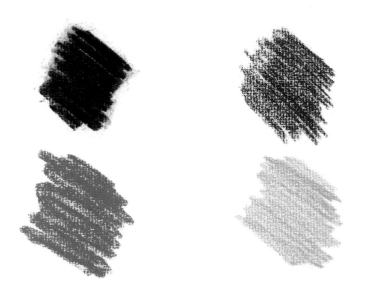

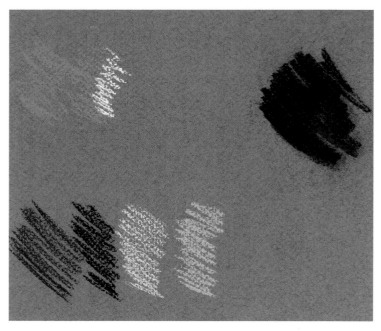

Textured and coloured papers, such as Ingres (above) and Tiziano (above right), come into their own as supports for softer materials such as charcoal, conté, pastels and crayon. Their surface patterns trap the pigment particles, heightening the effect of the mark. These papers come in numerous tints and the subtler, mid-toned greys and neutral shades provide a highly receptive and attractive background for monochrome drawings. The mid-tone is especially effective when heightening with white. When left exposed, the subtle shades can be used as an integral part of the image.

Cotton-rag hot-pressed paper permits the smooth laying down of watercolours and provides a very robust surface for linear pencil work; its high strength allows constant erasing and reworking without surface damage and makes drawings durable. It is also the best paper for silverpoint, its smoothness allowing the metal point to glide across the surface. Coloured crayon, both dry and wet, takes especially well to this surface.

Cold-pressed, or 'not surface', watercolour papers are perfect for watercolour and gouache media. They also work well in conjunction with natural charcoal and pastel by gripping the pigment particles within their surface texture, which produces a denser tone. Rough-textured papers tend to hold on to the pigment rather too much, making erasing virtually impossible.

Other equipment

Space and portability limit the amount of equipment that you can take to a life class and, in reality, drawing requires little equipment. It is therefore important that you choose pieces that are both functional and cost-effective.

Radial easel

The most vital piece of equipment is the easel and, if you are attending classes, it is likely that one will be provided for you there. The most common type is the radial easel, which has three splaying legs, and an upright section that can extend upwards to about 1.9m (75in) and be angled backwards or forwards. If well-maintained, the radial easel provides the most reliable support. It may also be folded into a compact length, making it a good choice for home use.

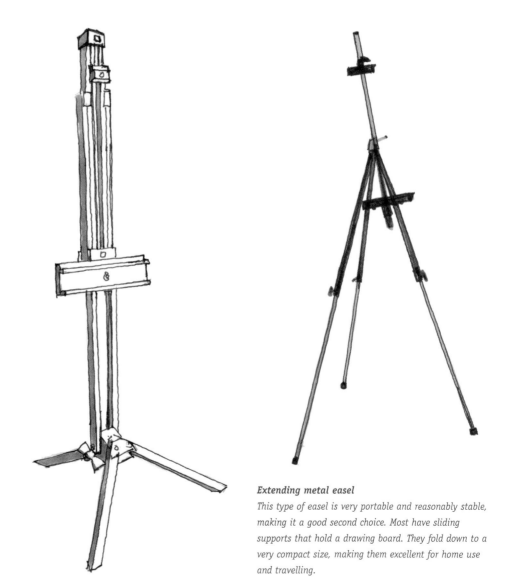

Extending metal easel

This type of easel is very portable and reasonably stable, making it a good second choice. Most have sliding supports that hold a drawing board. They fold down to a very compact size, making them excellent for home use and travelling.

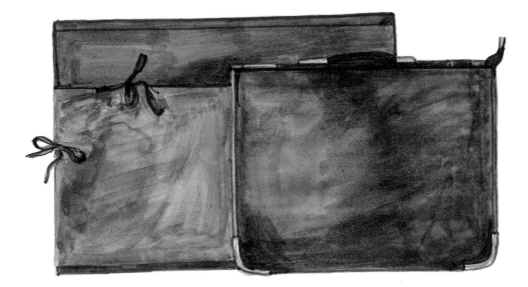

Portfolio

For transporting work, you have two options. A portfolio (left) will keep your work flat but its large size may be inconvenient, especially on windy days! A more portable alternative is a plastic tube (far left) that extends to about 60cm (24in), into which you insert your rolled papers. Once removed for storage, the drawings should be flattened and transferred to a portfolio.

Extendable plastic tube

Drawing board

Drawing boards are often provided in classes but if not, you will need one that is easy to carry. My drawing board, pictured, was made to my design in 2cm (¾in) plywood, with a handle routed out of the main body of the board. Plywood is the best choice as it is lightweight and will accept drawing pins. Masking tape is the best means of securing the drawing but should be removed as soon as possible, because many tapes increase in adhesive strength over time.

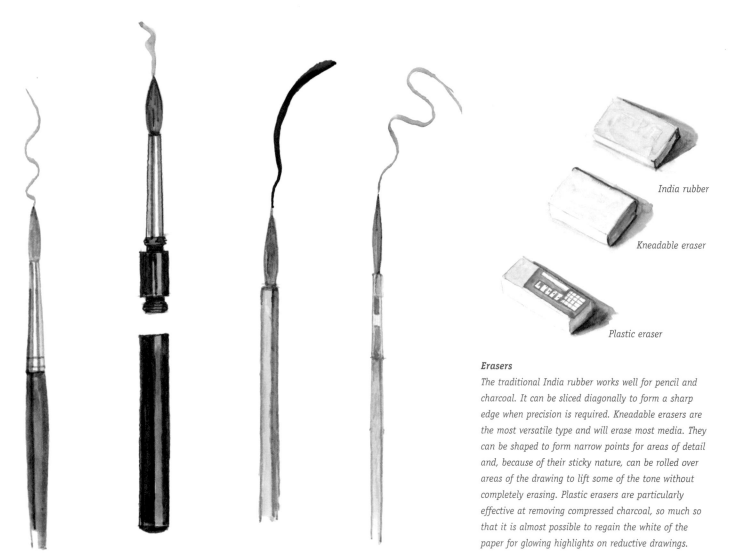

India rubber

Kneadable eraser

Plastic eraser

Erasers

The traditional India rubber works well for pencil and charcoal. It can be sliced diagonally to form a sharp edge when precision is required. Kneadable erasers are the most versatile type and will erase most media. They can be shaped to form narrow points for areas of detail and, because of their sticky nature, can be rolled over areas of the drawing to lift some of the tone without completely erasing. Plastic erasers are particularly effective at removing compressed charcoal, so much so that it is almost possible to regain the white of the paper for glowing highlights on reductive drawings.

Size six round sable *Pocket sable* *Chinese brush* *Sable quill brush*

Brushes

If you are concentrating mainly on drawing, you should not need too many brushes, and one high-quality brush is better than a bagful of poor ones. A good brush has a seamless ferrule (the tube from which the hair extends), inside which the hair should be securely fixed to avoid loss. The best hair is Kolinsky sable. It should have good spring, a generous belly to hold plenty of paint and should point well. A good choice is a size six round sable, with a good point and sufficient belly to provide a good brushload and precision in one package. Pocket sables

have removable tips and may be convenient at times. Soft Chinese brushes, which typically use goat or wolf hair, are relatively cheap and rely on a deftness of touch to keep control of the mark. They are particularly suited to a broad approach rather than precision work and perform well with Chinese inks. A favourite brush of mine is the sable quill brush, so-named for its use of a bird's quill as a ferrule. The crow quill shown has a slightly long hair and is excellent for precise, long, flowing marks. It is ideal for use with ink and watercolour.

Aerosol

Spray diffuser

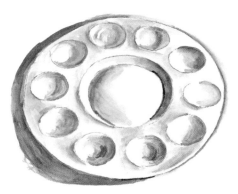

Palettes

There is a wide choice of palettes. Plastic ones like the one shown above are inexpensive, lightweight, unbreakable and easy to transport. Enameled plates are also a good, cheap mixing surface.

Fixatives

Fixatives (above) are sprayed on to a drawing to hold loose drawing materials in place. They come in two forms, aerosol and liquid. Aerosols are easy to use and provide a regulated spray without droplets. Spray diffusers draw fixative directly from the bottle. To use one, you blow directly over an aperture on the diffuser, which draws up the fixative as a mist, and passes it into a second tube that is aimed at the drawing. Spray diffusers may produce droplets that can ruin the drawing, so it's best to practice with water and scrap paper first. Fixative should not be inhaled and so should not be applied in warm or confined spaces.

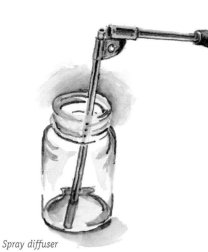

Acetate gridded viewfinder

Homemade viewfinder

Sharpening block

A sharpening block (right) is an effective means of putting fine, sharp points on knife-sharpened pencils. It consists of an emery paper attached to a wooden flat. This is the best means of getting the ultimate point.

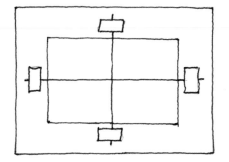

Viewfinders

Viewfinders take several forms, from a simple L-shaped card to those that allow you to gauge perspective. L-shaped viewfinders tend to become bent or torn. A simple homemade viewfinder to help with composition can be made from a card rectangle across which two (or more) threads are taped vertically and horizontally at measured positions. The most convenient type is a small, pocket-sized version containing a gridded acetate sheet. You can either buy one or make your own, and use it for both measurement and composition.

Recipes

Homemade materials offer several benefits. Homemade pastels, for example, save money and allow you to produce many highly personal tints. Making inks gives you insights into the world of the great artists and provides unique materials that are quite unlike their modern counterparts. Silverpoint papers are not easy to purchase. Those you can find tend to be bland and less sympathetic to this sensitive medium than home-prepared papers.

Homemade pastels

Ingredients
gum tragacanth
distilled water
alcohol
tights or muslin
several clean glass jars
dry powdered pigments (titanium white, yellow ochre and Venetian red recommended)
precipitated chalk
China clay

Rolling pastel dough

In a clean jar, moisten the gum with a little alcohol. Add 30 parts water to 1 part gum; leave overnight. The next day warm the solution by placing the jar in warm water; strain though tights into a clean jar labelled 'Solution A'. Divide Solution A in half and add one portion to a fresh jar labelled 'Solution B'. Mark the level and add two further parts water, then continue as summarized below:

Solution B = *1 part Solution A : 2 parts water*
Solution C = *1 part Solution B : 2 parts water*
Solution D = *1 part Solution C : 2 parts water*

It's best to make a white dough first, which can be combined with subsequent coloured doughs to create the reduced tints that you will need to work in pastel. To make your white dough, combine the following ingredients in a basin:
1 part titanium white
1 part precipitated chalk
½ part China clay

Mix well before adding enough of Solution C to form a firm dough. Cover a flat surface with newsprint paper and place some dough on to it. Cover the flat of your hand with newsprint and roll the dough from side to side until a thin sausage forms; leave to dry at room temperature for a few days before testing. Don't become discouraged if your first attempts at making pastels do not work; trial and error is a necessary part of the process. Keep notes of all results with an example and

description of the mark. Because raw materials vary it is not possible to give absolute measures but I have found solutions B and C successful with the majority of pigments. Any mixtures that resulted in brittle pastels benefited from increasing the proportion of China clay, which gave smoother, more robust results.

Iron-gall ink

It is known that iron-gall ink was used by medieval scribes. Iron galls, also called oak galls, are a part of the oak tree in which wasps like to lay their eggs. Oak galls are rich in tannin and gallic acid. When combined with iron sulphate they react to form a black ink.

Ingredients
3 parts by volume of ground oak galls
 (100g or 3oz is a good quantity to start with)
2 parts iron sulphate
1 part powdered gum arabic
2 rinsed eggshells
distilled water

Oak galls

Boil 12 parts distilled water and add the ground oak galls. After 15 minutes add the iron sulphate and pour through a filter. Separately add a small portion of the liquid to the gum arabic, making sure it dissolves completely. Add this to the main liquid mixture and pour into clean glass jars until needed. Add the eggshells to neutralize the pH of the ink.

The best quality oak galls still contain wasp eggs, making them richer in tannin. If the eggs have hatched, there will be a small hole where the wasps escaped. Iron gall takes about six months to reach optimum condition, by which time it will have darkened considerably. It also darkens further after application.

Silverpoint paper

The best surface for silverpoint is 100% cotton rag paper in hot-pressed (satin) finish. Stretch the paper on a drawing board, securing with gum strip. There are now two alternative ways of coating the paper; the first is simpler but the second provides the best surface.

Method 1 ingredients
Chinese white watercolour or gouache
water

Coat the surface with Chinese white watercolour or gouache mixed with an equal quantity of water, brushing on to the paper thinly.

Method 2 ingredients
1 part rabbit-skin glue granules
water
zinc white dry pigment

Prepare a solution of rabbit-skin glue at a ratio of 1 part glue granules to 15 parts water. Allow it to soak over night before warming it in a bain marie, or in a tin can inside a pan of water. Do not boil. Allow the solution to cool slightly before mixing it in a jar with zinc white dry pigment, using a stiff

brush to work out the lumps. The correct ratio of pigment to glue should have the consistency of single cream. Brush on to the paper thinly.

Preparing silverpoint paper

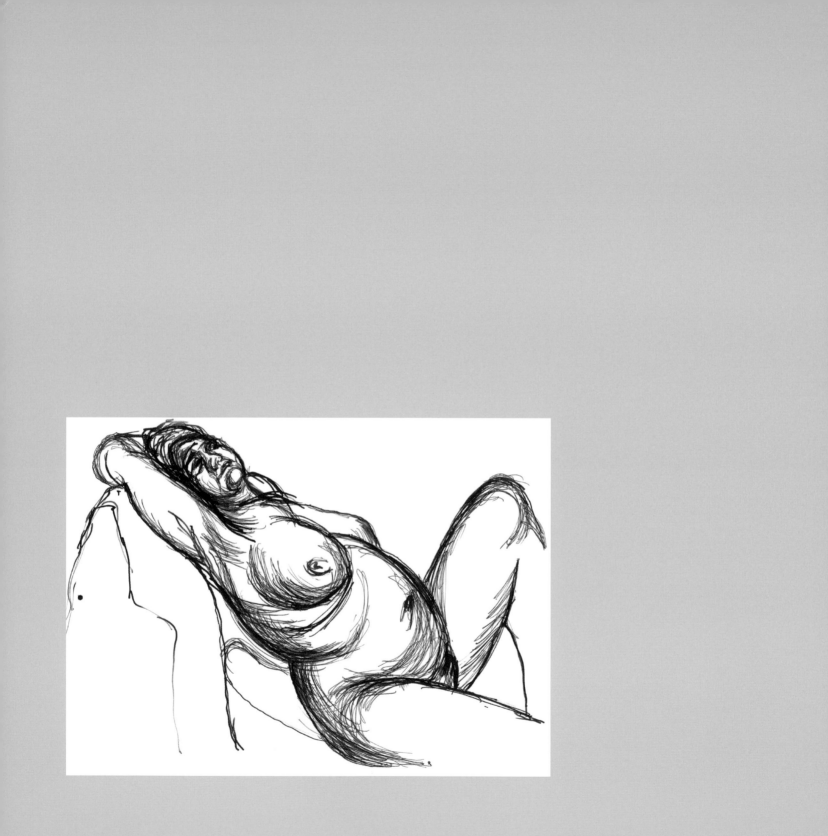

The human form

The skeleton

Some knowledge of the skeleton will help you determine and understand what lies beneath the surface of the body. You don't need to know a lot about anatomy, indeed too much information may obscure important issues, but the importance of learning what the visible structures are and how they connect with each other cannot be overemphasized.

Torso

The vertebral column, or spine, is located at the rear of the ribcage, which it supports. Due to its centrality, the spine is very descriptive of any twists and bends during poses.

The ribcage is responsible for the torso's cylindrical appearance and tapers towards the shoulders. At the front it connects to the sternum, or breast bone; at the rear, the head of each rib connects to a corresponding vertebra of the spine. Standing poses are good for highlighting the shape of the ribcage, particularly the base.

The clavicles, or collar bones, are an important frontal feature useful for observing balance, as are the scapulas, or shoulder blades, at the rear. The notch or gap between the clavicles is useful for observing the central line and checking alignment in all types of pose.

The pelvis is very descriptive of the balance of the figure, particularly when standing. The iliac crests make good frontal landmarks; at the rear the diamond-shaped sacrum is often visible as two depressions at the base of the spine.

Arms

The humerus is the only bone in the upper arm and, apart from the protuberances that form the landmarks of the elbow, is not very visible, buried deep under muscle and other tissue.

The radius and ulna form the forearm. The slight curve of the radius produces the characteristic shape of the lower arm.

Legs

The femur gives the thigh its slight curvature, and its head, a smooth ball, fits into a socket joint at the hip. At its lower end the femur forms two visible structures that rest on and articulate with similar ones on the top of the tibia.

The patella, or kneecap, provides a useful frontal landmark.

The tibia and fibula form the lower leg; the tibia is larger and visible throughout its length. It displays a sharp landmark below the patella and runs down to form the landmark of the inner ankle bone. The only visible part of the fibula is at its base, where it splays outwards to form the outer ankle bone.

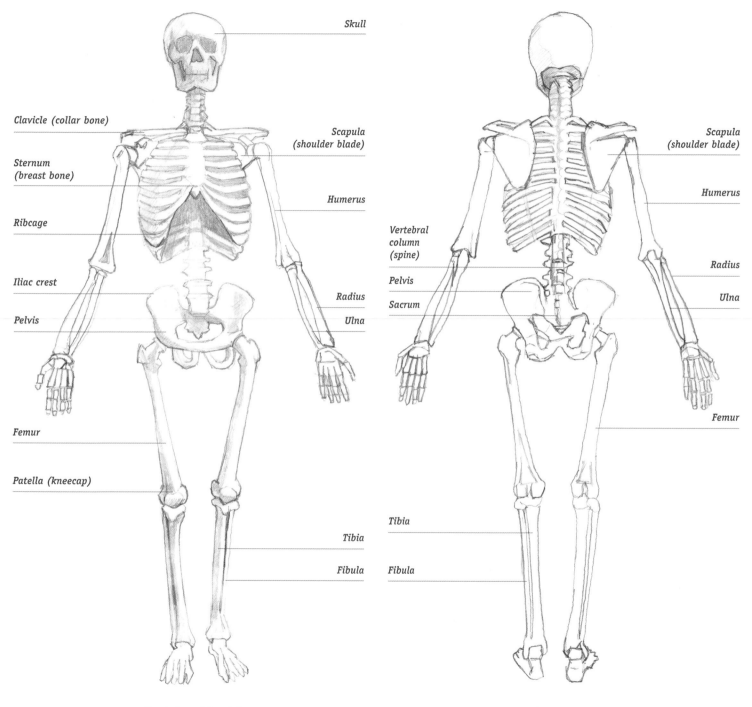

Skull

Clavicle (collar bone)

Scapula
(shoulder blade)

Sternum
(breast bone)

Humerus

Ribcage

Iliac crest

Radius

Pelvis

Ulna

Femur

Patella (kneecap)

Tibia

Fibula

Front view of the skeleton

Scapula
(shoulder blade)

Humerus

Vertebral
column
(spine)

Radius

Pelvis

Ulna

Sacrum

Femur

Tibia

Fibula

Rear view of the skeleton

The skull

The skull gives the head its shape and variations in shape between skulls are what make each head and face individual. The skull rests on the top of the spine and is divided into two parts, the skeleton of the face and the cranium, which contains the brain. The different sections of the skull are held together by sutures that resemble meandering rivers on its surface.

Skeleton of the face

The maxillary bones form the upper jaw, the roof of the mouth, the side wall of the nose and the floor of the orbits, or eye sockets. They also hold the upper teeth. The mandible, or lower jaw, is the largest bone of the face and the only moving part of the skull. It consists of a horizontal front section with steeply angled sides that connect with the temporal bone of the cranium; it also holds the lower teeth. The zygomatic bones form the distinctive landmarks of the cheekbones. The two nasal bones meet to form the bridge of the nose.

Cranium

The frontal bone forms the forehead and the roof and arch of the orbits. The occipital bone forms the back of the head and the external occipital protuberance is easily felt where the vertebral column enters the skull. The parietal bones form the two halves of the upper skull and meet on the central sagittal suture. The temporal bones are below the parietal bones at the side of the skull and below the zygomatic arch is the auditory hiatus (entrance to the ear).

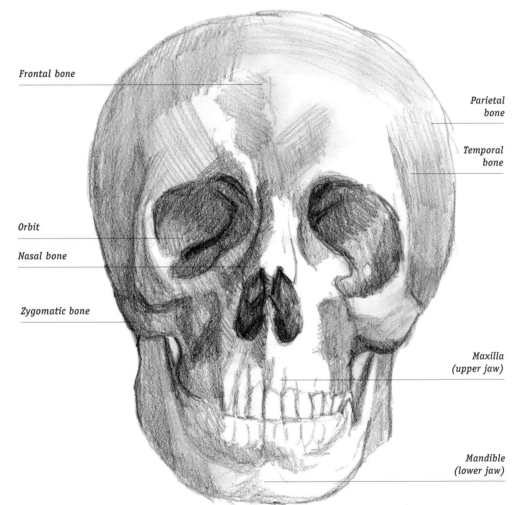

Frontal bone

Parietal bone

Temporal bone

Orbit

Nasal bone

Zygomatic bone

Maxilla (upper jaw)

Mandible (lower jaw)

Front view of the skull

Side view of the skull

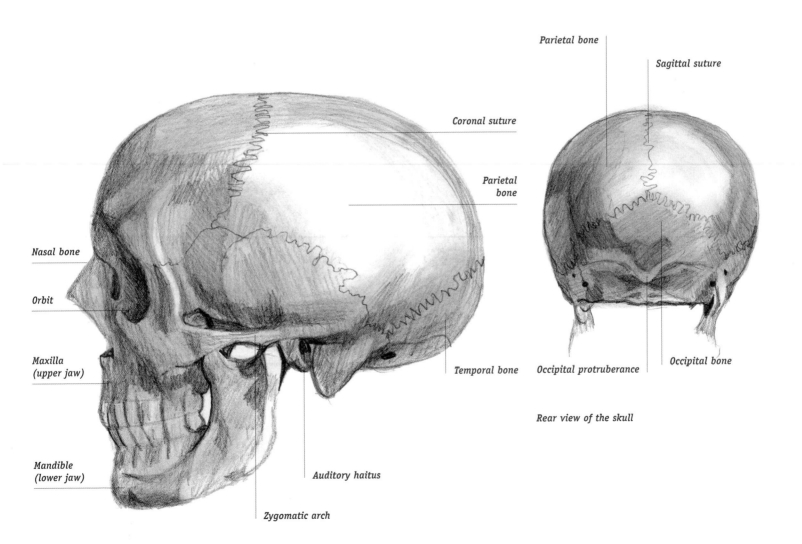

Coronal suture

Parietal
bone

Nasal bone

Orbit

Maxilla
(upper jaw)

Mandible
(lower jaw)

Temporal bone

Auditory haitus

Zygomatic arch

Parietal bone

Sagittal suture

Occipital protruberance

Occipital bone

Rear view of the skull

Muscles

Many influential muscles are deep layer and not revealed to us and it is the surface ones that count when drawing. Fit people tend to present better muscle definition because there is less of a covering of fat. Similarly, men tend to have better muscle definition than women (obviously female body builders are an exception) because women carry more fat.

Torso

The pectoralis major covers the breast area and is tensed in poses in which the body's weight is supported by one or both arms.

The external oblique curves around the side into the abdomen, which is dominated in the central area by the rectus abdominus. These muscles tense and are well displayed when the torso bends forward or twists.

The diamond-shaped trapezius fans out across the upper back, tapering down to meet the latissimus dorsi; both are well displayed during standing poses if the model's back is arched slightly and the arms are raised.

Arms

The deltoid sweeps around the shoulder from beneath the trapezius and is well displayed when the arm is raised to shoulder height. The biceps dominates the middle section of the upper arm, tensing when the forearm flexes towards the arm. At the rear, the triceps tenses when the arm is raised and extended.

The brachioradialis, flexor carpi radialis and the flexor carpi ulnaris are important lower-arm muscles that are highlighted well when a fist is formed with the wrist and elbows slightly bent.

Thigh and leg

The sartorius, rectus femuris, vastus lateralis and vastus medialis dominate the front of the thigh; below the knee the tibialis anterior dominates. All these muscles are displayed well when weight is placed on a slightly bent leg.

At the rear, the gluteus maximus, gracilis, adductor magnus and semimembranosus are well defined when the leg is lifted away backwards from the body while standing. The biceps femuris tenses when the lower leg is bent upwards. Below the knee, the gastrocnemius outer and inner heads soleus and Achilles tendon are normally visible but display well when the leg is bent, with weight placed on the ball of the foot.

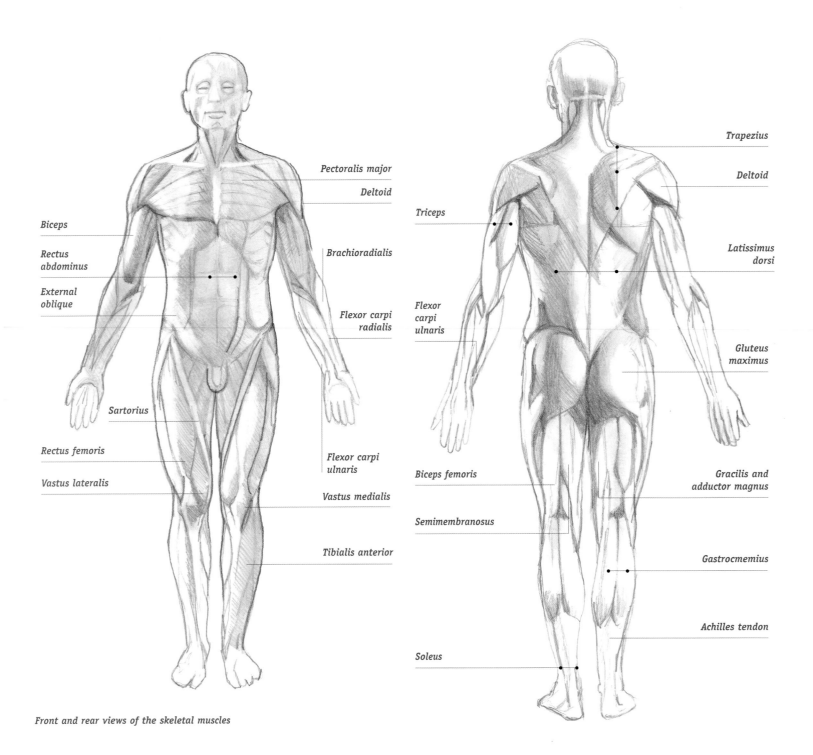

Pectoralis major

Deltoid

Biceps

Rectus
abdominus

External
oblique

Brachioradialis

Flexor carpi
radialis

Sartorius

Rectus femoris

Vastus lateralis

Flexor carpi
ulnaris

Vastus medialis

Tibialis anterior

Front and rear views of the skeletal muscles

Trapezius

Deltoid

Triceps

Latissimus
dorsi

Flexor
carpi
ulnaris

Gluteus
maximus

Biceps femoris

Gracilis and
adductor magnus

Semimembranosus

Gastrocmemius

Achilles tendon

Soleus

Proportion

It is important to gauge proportions when drawing the body – failure to do so will result in elements of the body that are too large or too small in relation to the rest of the figure. Observing these relative proportions is an important part of planning your drawing.

When proportion is not gauged and guesswork is substituted, the results can be catastrophic. It is common for inexperienced students to view parts of the body in isolation and begin by focusing on a single element, often the head. This might typically be placed towards the top of the paper and drawn fairly completely before the student moves down the body, only to find later that the model's feet will not fit on the sheet. If the head is proportionally too big, the student may decide to continue with the drawing and reduce the scale of the legs and feet, resulting in a body that is out of proportion.

Failure to understand vertical proportions in relation to horizontal ones can also have implications and will tend to result in the body being too wide or too narrow.

Advantages of understanding proportion

If you can grasp the fundamentals of proportion when the body is upright, then this will be a great help in dealing with the foreshortening effects of perspective when you view a prone figure.

Another form of foreshortening concerns the diminishing scale of features beyond the imaginary centre line that runs down the front of the body and head. Here again, some knowledge of average proportions will back up your observations and help you avoid the pitfalls.

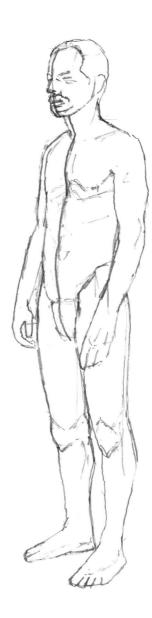

Three-quarter view of male

In a three-quarter view of the figure, any feature, such as an eye, hand or leg, on the near side of the body appears larger than its equivalent on the far side.

Gauging proportion

If you have some prior knowledge of the proportions of the average figure, male and female, you are better equipped to deal with the real thing when you face it, although measurement deals with the true proportions of each individual. The traditional gauge is to observe the number of times the head length fits into the total height of the body. The average adult person is seven head heights in length, giving a ratio of 1:7, but it is not unusual to arrive at 1:6.5 or 1:7.5 when measuring.

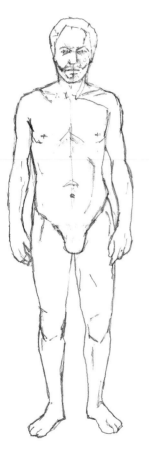 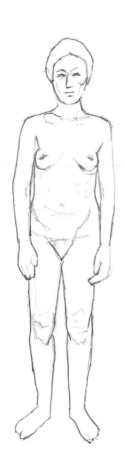

These drawings represent the average bodily proportions of men and women. Women have a wider pelvis and hips and lower buttocks. Men are narrower in the hips, have a wider upper body and greater muscle definition.

Form

What does the term form mean? When we are confronted with the human figure we are aware that it is three-dimensional and has substance, structure and volume. When we draw we are trying to convey visual facts about the subject to the spectator. A line drawing can convey balance, space, outline, and proportion, but in order to convey the form and volume of the body we may need to rely on other means.

Conveying the sense of form and volume of the figure in a drawing is a matter of searching for visual clues that tell us about the body's structure.

Beyond line

A major visual clue is given by light, which describes form by illuminating some areas while others remain in shadow. It is impossible to convey this effect using line alone. Imagine drawing a sphere using only line; it would appear as a disc on the flat of the paper. To transform the disc into a sphere we must use shading or hatching. Subtle shading in pencil is one way of conveying the sense of rounding. Tonal drawings, which use no line at all, can be highly effective – the approach is like carving with light to reveal form. The dramatic impact of charcoal is highly effective and works best on large-scale drawings.

Hatching is the use of close-set lines to convey tone and is distinct from other line work. The lines may be straight, curved or crossed. Curved lines that encircle the form rather like the contours on a map are perhaps the most effective at conveying form. The drawings of many Renaissance artists use this method perfectly, where the sweep of the nib or chalk moves with the contours of interior form, such as breasts or projections of muscle or bone, to convey the three-dimensional qualities of the body. This method may illustrate the form-

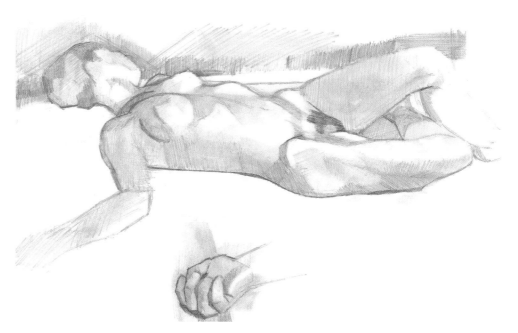

revealing effects of light, but may also convey the sweep of a curve or the change in direction of a plane where there is no light source that specifically emphasizes form. When dealing with such issues it is useful to keep the shading contained within the outline of the figure, as we are not really dealing with light or context.

Creative tone

A good way of conveying form is to work tonally within the confines of the body and its immediate surroundings, using line very economically. Here, the shading has been hatched and smudged and the range of tones is kept narrow. The shading is creating form rather than being absolutely faithful to the tonality of the subject.

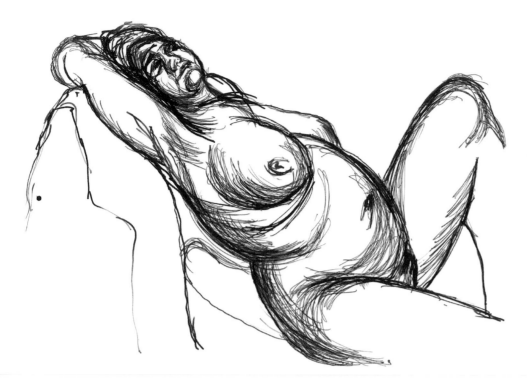

Curved hatching

In this ink drawing, the pen nib sweeps around the forms, laying down contour lines that amply describe the sense of mass and volume of the model. Different nibs, including steel, quill and reed, give variety to the weight of line to emphasize stronger forms. This type of drawing is as much about feel as what you see.

Sculpted figure

Studying casts is an effective aid to understanding form. The cast of a crouching youth that was the subject of this drawing had very little detail and provided the perfect opportunity to investigate volume and solidity. The absence of local colour, such as that of hair, encouraged the continuity of form through the fall of light over the body as a whole; local systems of shading would fragment the form.

Merging forms

There is an almost sculptural quality about the way the model in this drawing connects to the plinth, as though both were carved from the same block of marble. This establishes a continuity of form; as the rear of the plinth is on the same plane as the upper back of the model, both have received the same weight of shading even thought the plinth was white and therefore lighter than the model's back.

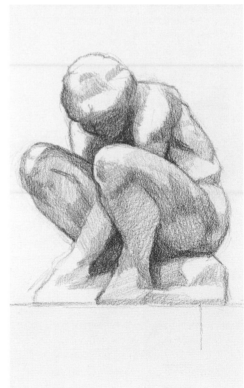

TIP

When studying form, try to ignore the smaller issues such as small landmarks, and concentrate on the bigger picture. If possible, try to bring out the sculptural quality of the subject by introducing shading to larger areas, such as entire sides of people and objects.

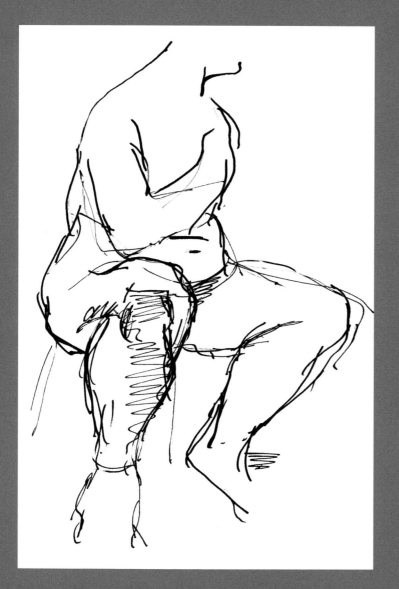

Techniques

Line drawing

Although lines often don't exist in the real world in the contexts in which they are commonly used in drawing – as edges or boundaries – line is the most natural drawing element that we can employ. It is descriptive and emotive and is our first form of language when drawing, making it closest to the handwriting of the artist than any other type of mark.

Types of line

The line is a strong element in drawing and in the world. The eye will be led quite naturally by some lines, but can be just as easily stopped by those that act as boundaries. In drawing, lines have the power to enclose and form shapes, and partially enclosed forms will be completed by the spectator's eye. A continuous line leads the eye on an interesting journey.

The edge line

When a line is used to suggest an edge, it can be expressed in a huge number of ways using a wide variety of media.

Solid forms may benefit from strong, firm lines and a firm, single line works well for hard forms, such as furniture, and for static elements in the space, such as room corners, windows and door frames. A strong line can convey a sense of assurance and certainty about the shapes being drawn.

Dark lines can emphasize an object's place in the hierarchy of space by bringing it forward; fleeting, faint lines do the opposite by placing items further back in space. A tapering, single line allows you to place emphasis where it is needed, for example on deep-set forms within the figure – possibly areas that are near to deep shadow.

Some drawings suggest a constant state of flux and in such cases the use of searching, reworked lines that probe may say more than a single descriptive one. The reworking of line without any erasing can give drawings an organic and living atmosphere and may also convey movement.

A tense or frail line can have a huge emotional impact on the drawing, evoking a sense of the artist's or sitter's sadness or discomfort.

Solid lines can give drawings a sense of certainty. In this example, crayon has created dense, hard lines that place great emphasis on edges, both within the figure and between different elements of the space.

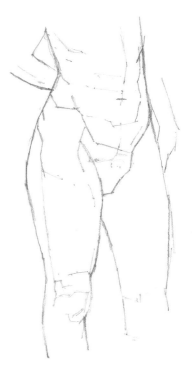

Rigid lines can be produced by sharp drawing tools, which may suit artists who are measuring and making their marks carefully and who want a degree of precision in the line. When the combination of hard and sharp pencil is used, the work can take on the qualities found in technical and architectural drawings.

Tense lines (left) are opposite in quality to solid and rigid lines, evoking feelings of frailty and uncertainty about the sitter or the artist. In this drawing, the line describes the rather emaciated appearance of the figure.

Using a blunt pencil or crayon allows flowing, organic marks well-suited to the human form. Here, terracotta crayon (bottom left) sweeps around the forms of the body to imbue the drawing with a sense of calm and rest.

The seductive lines of the drawing below, created using willow charcoal, have a beauty in their own right besides their ability to describe the rounded forms of the body. Ghost lines from earlier revisions seem to heighten the effect and give solidity to the figure.

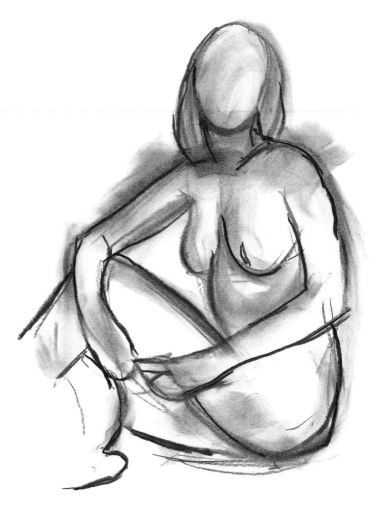

Internal lines

Within the figure, line can help to convey form and structure, and the line used may require a different weight or nature from those of the outline in order to set it apart. For example, line can be used to indicate internal boundaries, the points where changes in plane occur, and those boundaries perceived as being most important to structure might be given heavier weight than the outline. Line can also be used to create internal contour lines that encircle or sweep around boney or muscular landmarks, overlapping and tapering to hint at the projection of forms within the figure (see **Form**, *pp.54–55*).

Lines that reach and connect

Outside the figure, line plays an important role by helping to construct the pictorial space. Our awareness of perspective makes us look for lines that converge on a horizon, thus creating depth. And by using a continuous line, you can investigate positive and negative shapes, helping to create connections between separate elements of the space (see **Space**, *pp.78–79*).

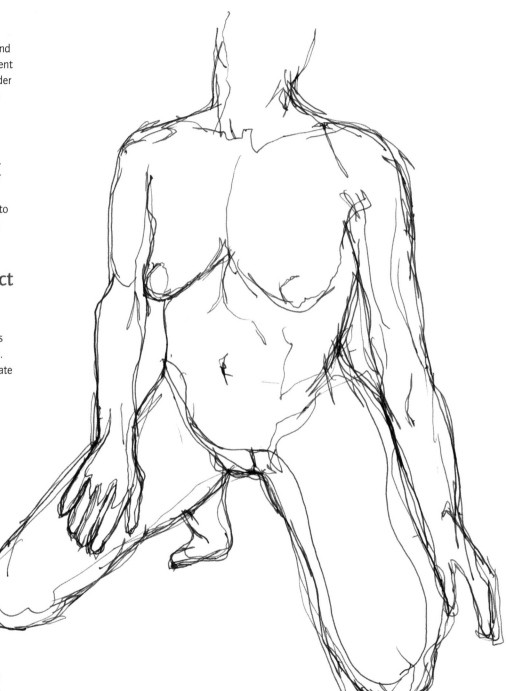

Continuous lines take on a very human and sinuous quality that works equally well for both edge and internal forms. When the model is muscular or lean, a continuous line that has been worked over many times can refine and emphasize this quality.

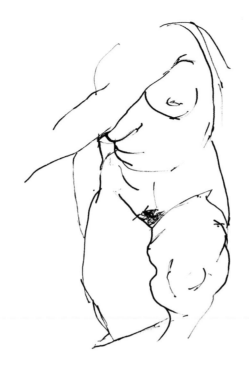

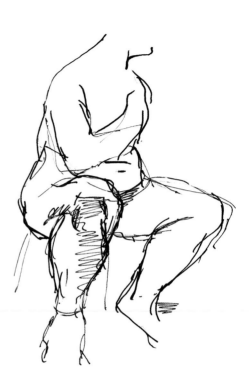

The interior structures of the body can be described by line. In the image above, pencil lines of varying intensities have been used to isolate different planes on the model's face. Greater emphasis has been placed on internal planes than on the outline.

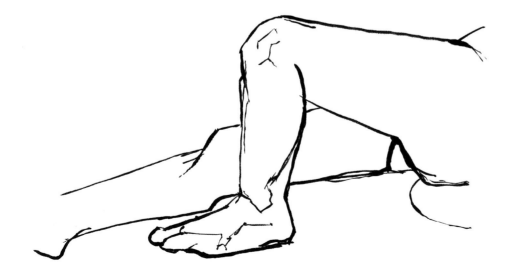

Dip pen lines (above centre) with tapering ends sweep rapidly and fluidly around the forms of the model's body to create a simultaneous sense of volume and movement.

Overlapping lines (above) can be used to create a sense of solidity, particularly at junctions where the body's forms overlap. The tapering nature of the dip pen has helped where a greater weight of mark has emphasized the forward projection of the knee.

Lines with varying width provide great scope for describing the complexities of the human form. In this drawing (left), a brush pen line exploits that variety as varying pressure has been used to spreads the pen's tip, giving great weight to the foot and outstretched leg.

Shading and erasing

Shading adds tone to line drawings, using the effects of light and shadow to imply form and pictorial space and helping to create a context for the figure. Shading may also add drama through the effects of light and shadow. But the most fundamental use of shading is to convey the form and volume of the body.

What is shading?

Shading is the process of adding shadow to a line drawing, or even drawing entirely by observing shadow, abandoning line completely. Shading is usually based on observing the effects of a given light source on an object. When the object is a person, matters become very interesting. Shading can also be added to drawings to describe form in the absence of a useful light source.

Types of shading

The way in which shading is applied influences the appearance and purpose of a drawing greatly. Using the humble pencil, a smooth continuous tone can be laid down. The effect may be soft, with subtle gradations of light to dark. Hard pencils are useful for placing more precise visual information into a drawing, while soft pencils have greater contrast with less subtle gradations.

Hatching is the use of repeated line to add tone to drawings. Hatching can be straight, giving dramatic, block-like lighting effects. Adding an additional layer of lines at a different angle, known as cross-hatching, increases the tonal range. Curved hatching is useful for reading the contours of the body, not unlike the contour lines of a map. Curved cross-hatching is even more descriptive, widening the tonal range. It can be

seen in the pen drawings of the Italian Leonardo da Vinci (1452–1519) and the pencil drawings of the Frenchman Jean-Auguste-Dominique Ingres (1780–1867).

Loose hatching, which requires the use of soft pencil, is a particularly vigorous form of shading. The Frenchman Pierre Bonnard (1867–1947) used this technique in his small-scale studies of the nude, in which he seemed to be able to root the figures in their environment.

Graphite provides us with perhaps the most versatile and controllable means of shading. Here, graphite stick has been laid down in a rich, continuous manner.

Hard pencil produces a tone close to that of the paper, creating a subtle effect that will give gentle transitions between light and dark. Although the shading has been applied in a directional manner, it still appears subtle due to the low contrast of the material.

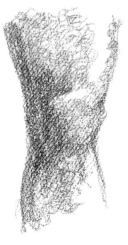

Shading that spiders around the paper, moving in all directions, may seem less mannered than directional shading. When the medium is crayon and the paper is textured, the shadows take on a sort of glow.

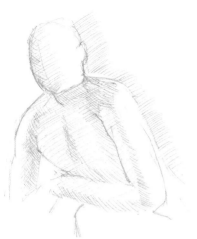

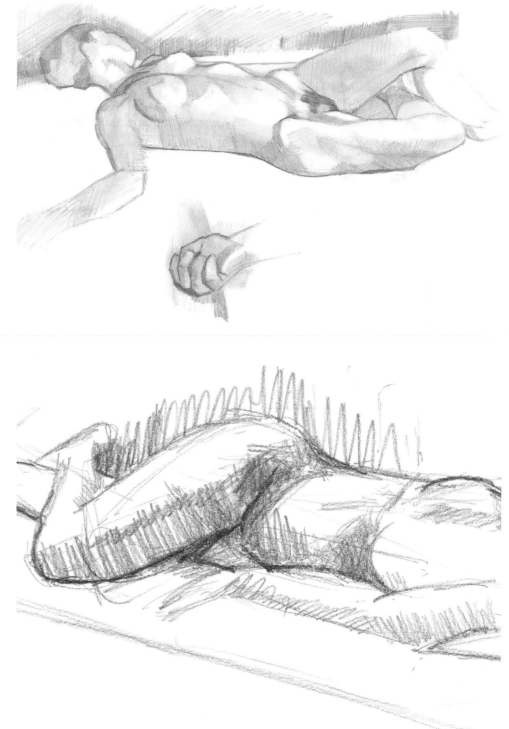

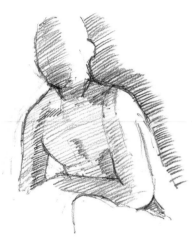

Straight hatching (above) gives a great sense of solidity and can be added gradually to a linear drawing to build structure. In the drawing above, soft pencil has been used to give a high level of contrast.

Cross-hatching (top) adds further depth of tone and softens the transition from light to dark. Hard pencil brings incisiveness to the drawing. Cross-hatching may contain more than two layers if the subject requires it.

Hatching and smudging (above right) softens the transitions between light and dark and also allows you to cover shadow areas quickly.

Vigorous hatching (right) in soft pencil or crayon may make a drawing more dynamic. It could be applied quickly and broadly to hint at shadow areas in linear drawings.

Shading materials

Pencil makes a particularly good shading material, being highly controllable and available in various grades that can be used alone or combined to give a wide range of tones. Hard pencils have lower contrast, allowing you to bring more information into your drawing, which is especially useful for the subtle gradations of form. Soft pencils, with their greater contrast, can give a harder feel to the drawing and lead to a greater sense of drama. Smudging pencil marks allows the fast application of continuous tone and may be done using fingers, tissue or, for greatest accuracy, a paper stump. Smudging can also be combined with hatching to great effect.

Willow charcoal is well suited to shading. It is soft, dense, fluid, easy to apply and erase, and is perhaps the best medium when the effects of light and shadow on an environment are the main issues.

Compressed charcoal lays down an even denser covering of black to very dramatic effect. It is less easy to erase, but this can be an advantage.

Conté crayons can be applied in several ways. Conté in stick form can be used to lay down a continuous line using the stick's edge, while hatching is straightforward with conté in pencil form. Conté pencils can also be used to produce drawings in the style of the Renaissance greats, Michelangelo and Raphael. Conté can also be applied dry and be overwashed.

Curved hatching is very descriptive of the body's forms, even in the absence of a useful light source. Pen and ink are particularly suited to this form of shading.

Patterns of dots make a very versatile form of shading. Varying the dots' density in certain areas is useful for the different forms of the body, such as this knee.

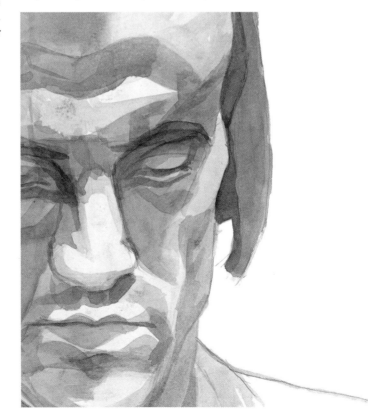

Adding an ink or watercolour wash produces a satisfying form of continuous shading. Adding extra layers gives more weight to areas where it is needed.

Erasing

Erasing is an essential technique for correcting mistakes or reworking parts of drawings. It is also a form of drawing in itself, albeit in a negative way, when used as a means of 'adding light' to reveal form. This technique is known as reductive drawing, since it reduces existing tone.

This purely tonal technique is based on erasing into a toned 'ground', which can be created by covering the entire paper with either charcoal or graphite then rubbing it in. The first marks are made with the eraser, picking out shapes in light. The drawing progresses by determining differences in tone between various elements of the subject. Additional charcoal or pencil may be added as the subjects dictate. This technique is well suited to drawings about context and form.

Basic India rubber can be cut and shaped to produce a variety of lines but better still is the kneadable or 'putty' rubber, which can be formed into useful shapes. This is particularly good for reductive drawings, where it can be used to stipple as well as erase. Where it is necessary to erase back to the white of the paper, a plastic eraser is without equal.

Adding powdered graphite or graphite crayon to a paper and burnishing it into the surface gives a mid-toned ground. This can be erased into and is useful for work where light and context are being explored.

Compressed charcoal rubbed into the paper produces a rich, mid- to dark-toned ground. Kneadable or putty rubbers can be used to stipple and erase into the ground, while plastic erasers are highly effective for erasing back to the white of the paper.

Using templates for erasing helps you to achieve sharp edges in combination with charcoal. Ready-made metal templates are available in a range of cut-out shapes, but you can improvise with paper or card. The hard-edged effect produced is useful for crisp highlights and outlines.

Introducing colour

There are occasions when the main area of interest in a drawing lies in the colour of the subject and there is the need to record it. Sometimes it is a matter of wanting to take a drawing just that bit further than a purely tonal rendering of the subject.

When introducing colour into drawings, it is important to have an awareness of how the type of light you are working in affects the colour in the subject. This is particularly important in life drawing because flesh is one of the more difficult subjects to read in terms of colour.

Natural light is the best light in which to observe flesh because it produces the greatest clarity of colour. Natural light is often cool, which results in warmer shadows; conversely, when the light is warm, cold shadows result.

Artificial light offers challenges by making flesh colours more ambiguous, especially if a scene has various light sources of differing temperatures. Generally, when a light source tends towards a particular colour the shadows will be the complementary colour of the light source (see **Making a colour wheel**, *oppposite*).

Suggested palettes

Working with as few colours as possible will help you to absorb colour knowledge thoroughly and gradually, while keeping your kit small, which allows faster work in the life room. In addition, the smaller the choice of colour, the greater the chance of your mixtures being harmonious.

Pencils

When using coloured pencils, begin with a set of 12, which should include a warm and cold version of all the primaries along with green, some greys, black, white and maybe some earths. See what these do and persevere before adding further hues. Mixtures are made optically by overlaying colours, so it is not necessary to go overboard.

Mixed media

In the excitement of the life room you may have an urge to mix one medium with another, perhaps because the chosen medium is not having the desired effect. Certain media combine effectively. For example, water-soluble pencils combine well with watercolours, both under and over them. Watercolour can be taken a stage further with gouache, and gouache and pastels are so alike that they combine extremely well.

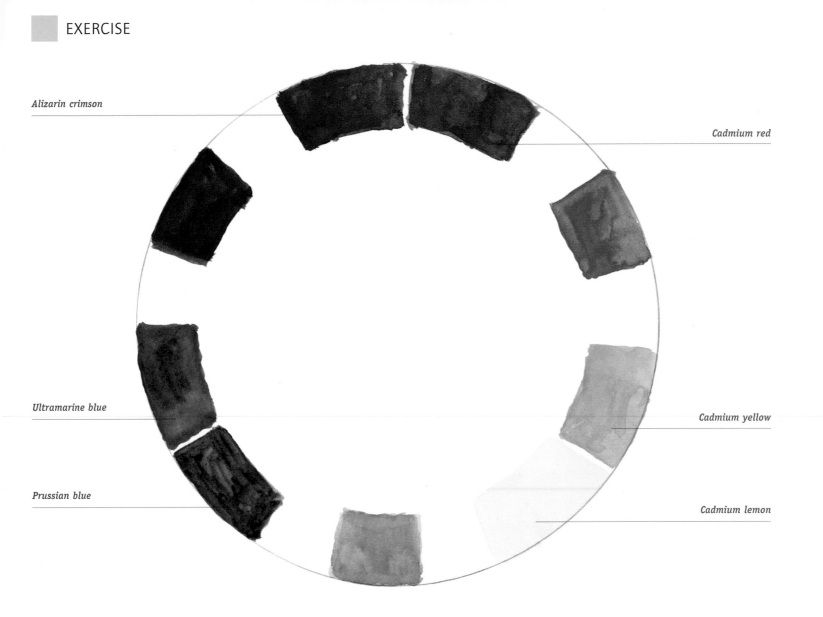

Alizarin crimson

Cadmium red

Ultramarine blue

Cadmium yellow

Prussian blue

Cadmium lemon

Making a colour wheel

The basic primary colours are red, yellow and blue. For your colour wheel, wou will need two versions of each in order to be able to mix a broad range of colours: cadmium yellow, cadmium lemon, cadmium red, alizarin crimson, French ultramarine and either Prussian or phthalo blue.

There is logic to how the colours are positioned on the wheel and it is based on their undertones. Each of the primaries has a tendency towards a secondary colour. Cadmium red has an orange undertone, whereas alizarin crimson's is violet. Ultramarine has a violet tendency,

whereas Prussian blue tends towards green. So the primaries reach towards a secondary. This is apparent on the wheel, where secondary mixtures appear as single blocks between the clusters of primaries. I prefer to think in terms of these undertones than the commonly used terms 'warm' and 'cold'.

To make the cleanest colours, you should avoid making your undertones clash. For example, mixing Prussian blue with cadmium lemon would make the cleanest green, since both have a green undertone. But if ultramarine,

a violet blue, is mixed with an orange yellow such as cadmium, a certain greying down is to be expected. However, these greys can be very useful for flesh.

It is easy to read the complementary of a colour by drawing an imaginary line across the wheel. But without the wheel to hand, you should think of the complementary as being the mixture of the two remaining primaries. When a complementary is added to a colour, it is neutralized.

Gouache earth colours

For gouache, I would recommend starting with earth colours, the range being yellow ochre, Venetian red, black and white. Just these few will allow you to render the tonality of the subject and hint at colour, which can be seen in the range of flesh-like tints prepared.

Gouache primaries

Once you have got the measure of these colours you can then try a primary colour-based palette that uses a crisp lemon yellow, cadmium red and French ultramarine. Again, you can see the potential to mix a vast number of very useful hues, including some that are very similar to the earth-based selection. What is impressive is the number of useful browns and greys, in addition to the brighter pinks and oranges.

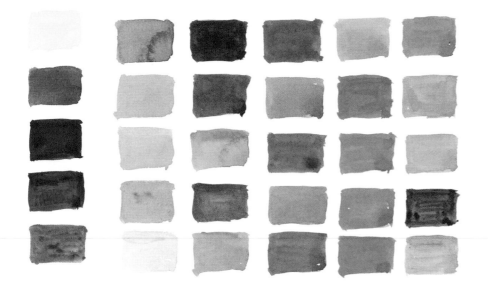

Watercolours

With a basic selection of cadmium lemon, cadmium red, alizarin crimson, ultramarine blue and Prussian blue, a range of useful tints has been created, and this is really just the tip of the iceberg. Rich reds and oranges, useful violets and greys, and earthy browns and olive greens are all possible. These colours will relate better to each other as they come together in mixtures. There is a simplicity and directness to this palette.

Colouring with conté crayons and pastels

Conté crayons (right) lend themselves to the subtle suggestion of colour rather than literal representations. The classic arrangement is to use a neutral mid-toned paper and to draw on this in sanguine, white and black. This gives a range of tones and hints at the pink nature of flesh. Variations on this theme would be to add yellow ochre, bistre and Naples yellow to give a full range of flesh tones that will allow you to work with some speed.

Pastels generally require careful handling and storage so, for the life room, try to limit the number to 10 sticks that will fit into a small tin. Because mixing pastel colours is not strictly possible, you need to choose carefully. Go for gentle transitions of colour and tone. A good range would be based around tints of yellow ochre, warm earth red, cool earth red and a warm grey or olive green, and would perhaps include raw umber for dark-haired models.

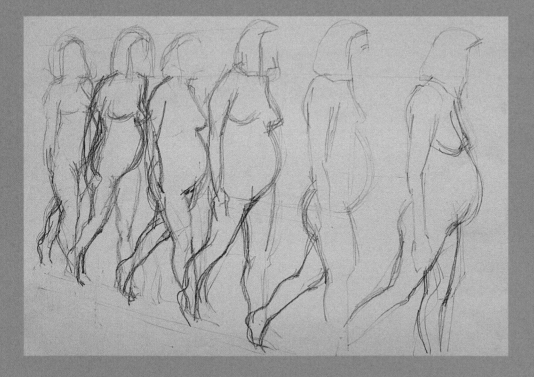

Making drawings

Coordinating hand and eye

You may well regard your first attempts at life drawing as disappointing. Factors that tend to work against the novice include nerves, excess energy preventing a focus on the subject and – the biggest obstacle – our pre-conceptions about the body. It's important to break down these obstacles which block the pathway between what we see and the paper. There are two main strategies for achieving this, rapid drawing and blind drawing. The ideal rapid drawing would be a fusion of the two methods.

Rapid warm up

Rapid drawing is a good way to start a class, functioning as a warm-up period, burning off any nervous energy and getting the process kicked off in an exciting way. Select a bold material such as charcoal, and the cheapest paper, newsprint, and work quickly. Rapid drawings are an excellent way of gaining confidence – their almost 'throwaway' quality usually produces good, strong results.

The physical set-up in the studio can have a huge impact on your ability to see. Your easel should be fully upright and positioned so that you can take in a view of the model and your drawing in one simple eye movement. With this distance reduced, a brief after-image is projected on to the paper, and this can be followed to plot the drawing on the page. Too much head or body movement loses this connection and will prevent you from maintaining a constant viewing position.

A rapid drawing should cut to the essence of the pose; your drawing may begin as a stick figure as you try to establish the axis of the main forms of the pose and convey its balance. Start with 10 minutes and eventually reduce the time to 30 seconds – a daunting task but there is something liberating about such brevity.

The series of blind drawings below was made while looking only at the model. At times the results of blind drawing may not even resemble the human form. It's important not to worry about accuracy but to see the drawings as a process of forging links with the subject.

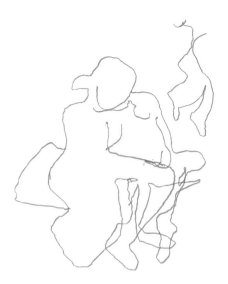
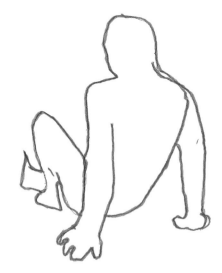

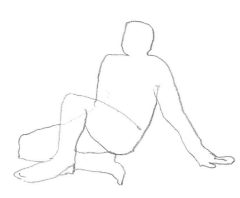

Blind drawing

This blind drawing made towards the end of a session (left) shows a high level of competence, with the figure beginning to resemble a person. Features such as hands and feet often become very sturdy due to the focus on fingers and toes. Once this stage is reached, it is usually time to stop – the drawings have served their purpose.

Blind drawings

Blind or contour drawings are perhaps the best way of strengthening the connection between eye, hand and drawing. Novice students spend more time looking at their drawings than at the model, leading to preconceptions taking over – the link is severed and the drawing loses authority. Drawing the model without referring to the paper reverses this trend and forges a stronger connection. So that you are not tempted to look at the drawing, position yourself slightly in front of your easel with your working arm free to roam over the paper. Look at the board just once in order to decide the starting point. Draw at a slow pace to maintain a sense of contact. Do not lift the pencil from the paper and, as you draw, place your trust in your eyes while 'feeling' your way around the body using a continuous line. If you reach the end of a form or need to move to new points within the outline, you may look while you reposition your hand to start to tackle a different part of the figure. The results are likely to be distorted but remember that the aim is not accuracy but a feeling of connection to the subject.

Semi-blind drawing

If you combine blind drawing with rapid drawing, you will spend perhaps three-quarters of your time looking at the model, leading to a real sense of connection. In the 'semi-blind' drawing below, the pencil was hardly lifted from the paper. The single line followed the boundaries of shapes, knitting the figure into the set-up.

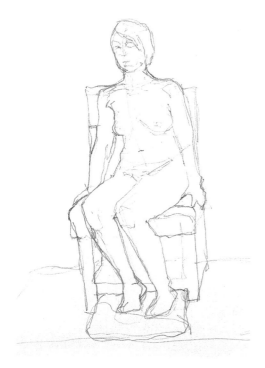

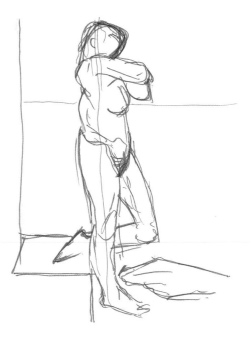

Rapid drawing

The rapid drawing above was made in about two minutes immediately after a session of blind drawings. The drawing began as a stick figure, to establish the main axis and read the body's balance. As confidence in rapid drawings increases, an increased sense of connection with the subject is felt.

TIP

Make each blind drawing in a different colour in case your drawings overlap; you will then be able to discern each separate one.

Composition

Composition involves organizing the elements of a drawing to form a successful whole. A drawing is well composed if its constituent parts gel together to form a pleasing shape when viewed in abstract terms. When the subject is a person or a still life, the matter is made slightly more complicated by the need to imply space while working well on an abstract level. It is the marriage of these two considerations that ensures that our drawings are successful.

Life drawing usually involves limited time with the model, which may lead to a lack of preparation. The result may be drawings that have the appearance of being thrown together and that have taken on a rather arbitrary quality. Figures are commonly placed too low on the sheet so that they appear to be falling out of the drawing. Or the figure in the composition may be too small and fiddly for you to enjoy the process of drawing. Worse still is when the figure doesn't fit into the constraints of the drawn space, often resulting in the feet having to be missed out or their size severely reduced. The latter two situations are issues of proportion as well as of composition.

Planning the drawing

Weighing up your subject before starting your drawing will be time wisely spent. You should be looking for strong shapes or patterns and elements of the subject that balance one another. This could involve basic geometry in which elements in the drawing have a degree of simple symmetry or happen to form triangular or cruciform arrangements.

Before starting drawings it's good to make some quick thumbnail sketches on scraps of paper no bigger than A6. No details are needed, the aim being to decide where the model will be placed in relation to the centre point and edges of the space. You'll find that thumbnails help to determine the shape of the drawing and where its

edges and centre coincide in space. The small scale makes it easier to see if the idea could be successful. Continue sketching thumbnails until you are happy with the composition. At this stage you're also looking at positive and negative shapes created between the model and his or her surroundings or with the edges of the picture space; these are the pieces of the jigsaw that, when slotted together, create interest in the drawing.

Shape and format

Although we are used to the convention of the rectangular format – upright for a standing pose, horizontal for a lying one – we should not be afraid to challenge this. Why not use a square format or place a lying nude within a vertical one? It is just such challenges that can make drawings successful and exciting.

Using a viewfinder
In the first view (above, right) the model would be positioned halfway down the page and slightly to the right; the figure looks perhaps too low in the proposed drawing. In the second view (right) the model is higher up, giving the viewer's eye more pictorial space before reaching the model. The overall shape this view provides is better and would result in a stronger composition.

Viewfinders

There are different types of viewfinder but the most useful is pocket-sized and consists of a frame surrounding a grid, often marked on acetate. The distance between the viewfinder and your eye alters its function: at arm's length it functions as a measuring device; held close it aids composition. You can move it back and forth to find an edge or corner of a composition, and use it to help select a portrait or landscape format. Then select a cross-point on the grid and line it up with a key landmark on the figure to begin measurement.

You can buy a viewfinder or make your own by taping threads at regular intervals across a mountboard frame to form a grid. Alternatively, draw a grid on to acetate (see **Other equipment**, *pp.38–41*).

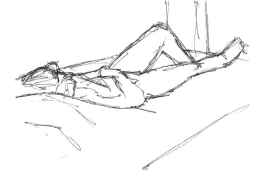

Preparatory sketch

When a figure is lying down it is natural to opt for a landscape format for the drawing (above). Here, I made a thumbnail sketch that places the model in a horizontal format. Compositionally this format works well, giving plenty of space around the figure.

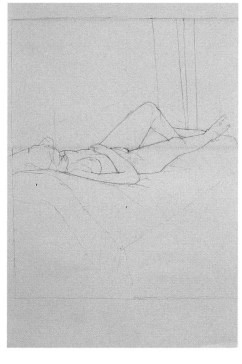

Intermediate sketch

A second thumbnail sketch has the model contained within a vertical format (above), with the centre of her body coinciding deliberately with the centre of the drawing. This composition is stronger and helps to place the figure in a context. The advantage of the thumbnail is that such fundamental decisions can be arrived at early on.

Finished drawing

The finished drawing (left), highly measured, benefited from the time spent making the two thumbnails to explore the compositional possibilities. The thumbnail also allowed me to decide where the main drawing should end in relation to the model.

TIP

A centrally placed object tends to look as though it is nearer the bottom of the drawing than the top, so position it slightly above centre. Having plenty of space at the bottom will lead the spectator's eye into the drawing.

Context

When we draw the nude there may be a tendency to view it in isolation – it is after all a wonderful subject. But if we draw the figure in context, we can bring a new level of ambition to our drawings. The figure may be engaged in some activity, rather than just posing; the figure dressing or undressing, bathing or drying itself suggests a narrative. By bringing the various elements together we are starting to work towards composition.

Context develops the pictorial sense of a drawing, requiring that you build a space to contain the figure, like a stage or film set, and consider placement, perspective and the effects of light. In the worlds of film-making and photography, creating a context, developing a narrative or setting a mood are major aims in which the visual success of a scene or photograph may lie.

It pays to spend time composing or planning the main elements of a set-up (see Composition, pp.74–75). Composition is partially a process of weaving different elements together to form a unified, well-planned whole. It is also about having a degree of control and making decisions for the sake of the drawing rather than being totally faithful to the subject. Your drawing could have the same level of ambition as a painting – the higher your goals, the greater the rewards.

Mood and narrative

The creative use of light and shadow can be used to set the mood and give a sense of time or place. A contextual drawing may have a narrative; it may tell a story about the model, artist or situation. By adding props or everyday furniture it may be possible to alter the mood. Bathing scenes and dressing or undressing are common activities used to create context, and the model may be partially clothed or items of clothing may be nearby. If it is not possible to change the atmosphere of the life room, drawings made there may be used as the basis of a composition worked on at home.

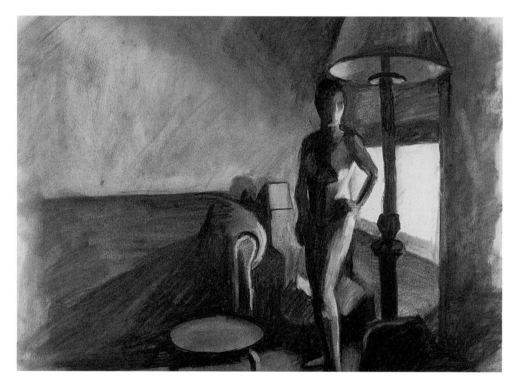

Domesticity

Dramatic light was the inspiration for this reworking of a drawing started in a life class. The play of light as it travels across the model and furniture, such as the lamp in the foreground, establishes an obviously domestic context. In this sense, the drawing works on a compositional and contextual level.

Placement of the figure

When placing the figure, think again about the set-up in filmic or photographic terms. Placing the figure close to yourself may convey feelings of intimacy, while props in the background contribute context. In contrast, placing the model further back in space may evoke a sense of vulnerability and isolation. If you have more than one model, you may want to create links between them to develop the narrative. It may be possible to arrange the figures so that they create interesting negative shapes in the space between and around them.

You may also want to bring a sense of motion into the scene to further elaborate the context. One way of doing this is to position and draw the model posed in several locations in the set-up.

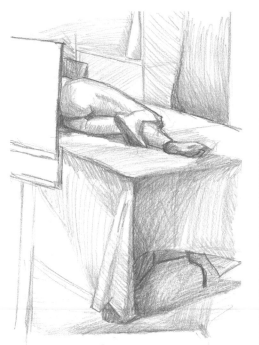

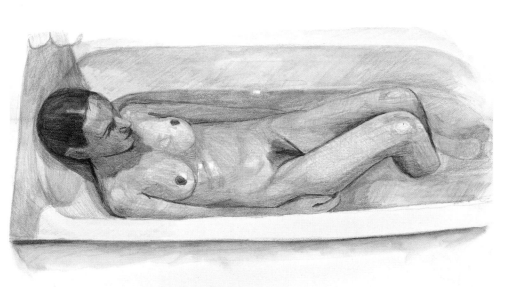

Life drawing

For this rapid drawing (above left), which took 20 minutes and was obviously made in a life room, I took a position from which foreground objects created a context. The model is deliberately cropped by a student's drawing board, further emphasizing the context.

Two figures

When a second figure is introduced (above), the atmosphere of the life room can change, increasing the opportunities for implied narrative – who are these people and why are they next to one another? Two figures also provide new compositional opportunities using the shape of the space between and around them.

Bathing scene

Coloured crayon was the medium for this drawing made over several sessions. It works as a study of the nude figure that presents challenges in depicting form and understanding colour, but it also places the figure in a domestic context. This drawing has a level of ambition akin to that of a painting.

Space

So far the figure has been the central issue, but if you want bring in the wider issues of life drawing, then you should also consider the space that the figure inhabits. To construct a pictorial space – an illusion on the paper – you need to develop an awareness of how you see things. This awareness relates to issues of perspective, measurement and proportion.

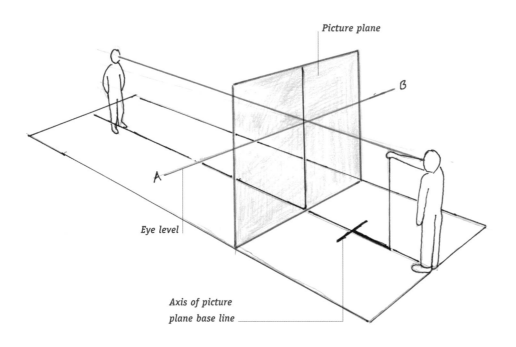

Picture plane

B

A

Eye level

Axis of picture plane base line

Locating the picture plane

The picture plane can be envisioned as the net on an imaginary tennis court and lies at right angles to the artist's line of sight. It may be helpful to put down some cues to help locate the plane. In this example, the artist has dropped a plumb line to the floor then aligned a stick with it, locating the direction of the line of sight. Another stick is placed at right angles to the first, establishing the axis of the picture plane base line. The blue lines are at eye level. Note that the picture plane or 'tennis net' is moveable along the line of sight; it could be right up against the artist's nose or against that of the model. It is the direction of the plane that is important.

If you regard the paper as an imaginary void in which you want to construct a representation of what you see in real space before you, you need various means to navigate your way around and explore the space. Measurement can help you plot where you should place elements within this void, but you need to lay down some foundations first.

Picture plane

One fundamental foundation is the picture plane, which is rather like an imaginary pane of glass between you and the model. The plane lies at right angles to an imaginary line that connects your eye to the centre of your field of vision. The beauty of establishing this plane is that you can compare all angles in relation to it. It's easy to make assumptions about angles, one of which is that a particular line, of a bed or table for example, is horizontal (parallel to the picture plane). But it can be horizontal only when you face it directly. If you were to shift your picture plane by turning slightly, you would notice that the line would no longer be horizontal. You can use your picture plane base line (see below) to make a comparison. You can also check horizontals by balancing a short steel ruler across the knuckle of your index finger and pointing to the centre of your field of vision; this creates a horizontal that can be used to determine angles. Another important foundation is establishing eye level, which helps in observing the effects of perspective.

TIP

To understand the concept of the picture plane in context, imagine an aerial view of the studio and your position in relation to the subject. If necessary, plot a map in thumbnail form, allowing yourself a maximum of five minutes to do this.

Filling the space

Being aware of the space between you and the model is valuable. Placing objects between you and the model may help to create the illusion of space in your drawing, as may placing objects between the model and the furthest point in the space. It is also helpful to forge spatial links between close and distant elements and to look for rhythms between them. One effective way of doing this is to identify negative shapes – the shapes created between positive forms. We find it easier to recognize and draw shapes than line, and the interlocking quality of these jigsaw-piece shapes can be of great help. One of the great surprises is that pictorial space can be constructed with line alone.

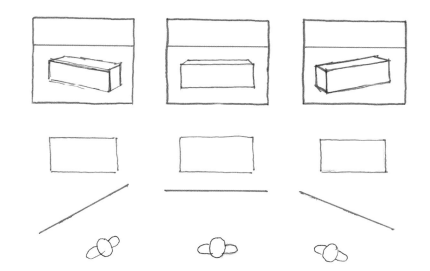

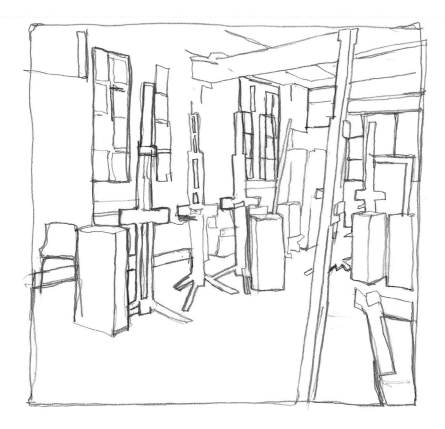

Picture plane and perspective
When a line on an object, such as the edge of a bed, is parallel to your picture plane, the line should appear horizontal in your drawing. If you change your picture plane so that it lies at a slight angle to the object, the effects of perspective will come into play. It is easy to overlook such effects if they are subtle, and a common mistake is to assume that slightly angled lines are horizontal. So there is great value in being able to establish the angle of your picture plane. Notice the change in angle of the box as the picture plane shifts in the example shown here.

Illusory space
Nothing creates the illusion of space in a drawing better than observing the various elements that fill it. In this drawing a continuous line takes a journey around the negative shapes and outlines of a life room, establishing links between near and distant objects. This type of drawing gains momentum as the eye becomes more attuned to the subject.

Perspective

Perspective is an optical illusion that causes objects close to us to appear larger than more distant ones. Using perspective effectively in your drawings will help you create the illusion of space on the flat surface of your paper, but perspective is of limited use when drawing the human form. It is, however, important to understand the effect of perspective in foreshortening the body.

Perspective is a complex issue, but *too* detailed a study will not help when you're facing the model in a life room. Your use and understanding of perspective should be based on the observation of angles in the working situation; you cannot impose a false perspective. There are three types of perspective that you will encounter in the life room: one-, two- and three-point, which have various effects, including the convergence of parallel lines and foreshortening of the body.

Points of perspective

Try viewing a cuboid box straight on so that its front surface is parallel to your picture plane. Its opposing sides will appear to converge to a single point on the horizon – the vanishing point. You will notice similar effects in the room you're in.

The vanishing point is at your eye level and any horizontal line or surface will converge towards it. In a square- or rectangular-shaped room, horizontal lines below your eye level, such as those where the floor joins the walls, will rise to the vanishing point. Those above, where the ceiling joins the walls, will fall to it. So knowing your eye level is very important.

To determine your eye level in the life room, either mark it on one of the walls, or observe lines that appear to rise or fall very little to the vanishing point; your eye level will be close to these. Shifting your point of view sideways or up or down, so that the model is viewed at an angle, introduces two- and three-point perspective.

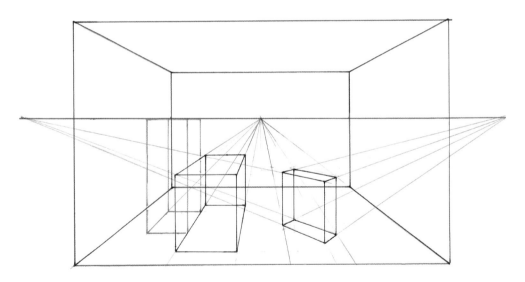

A room in perspective

The lines along the sides of the floor and ceiling in this image converge towards a central vanishing point, as do those of the red and green boxes. This is because the front and rear surfaces of the boxes and the rear wall of the room are parallel to the picture plane, while their sides are parallel to the observer's point of view. The green box is the same height as the observer's eye level, which is represented by the blue line, so the top of the box is not visible. The purple box is angled away from the picture plane and it is possible to trace the convergence of its lines to two vanishing points that are outside the boundaries of the room.

Viewing the figure

When you are in close proximity to the model the effects of perspective will be heightened. Any horizontally aligned features on the model at your eye level, regardless of the angle at which you are viewing them, will appear horizontal. Horizontally aligned features above eye level will converge downwards, those below upwards. In practice you may observe features converging on two vanishing points, known as two-point perspective. If the model towers above you, or you tower above them, you will be likely to observe the effects of three-point perspective. Another issue arising from perspective is that of diminishing spatial relationships as objects or people move away from you, known as foreshortening.

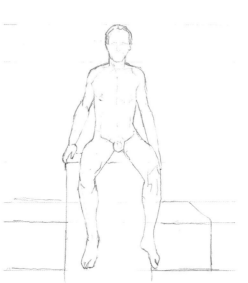

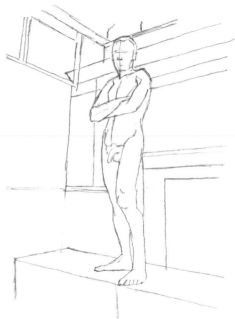

Three-point perspective

If you look up or down at an object, and to some extent the human figure, vertical lines will appear to converge to a third vanishing point above the ceiling or below the floor. If you now view the figure from a low angle, three directions of convergence can be detected: the alignment of features on the body converge to the left; horizontal lines on the left wall of the room converge to the right; and vertical lines converge upwards.

Single-point perspective

As the observer of the image above, you are viewing the figure straight on, parallel to the picture plane. You can discern a single vanishing point by observing the convergence of the top edges of the plinth. The eye level appears to be just at level of the model's lowest rib.

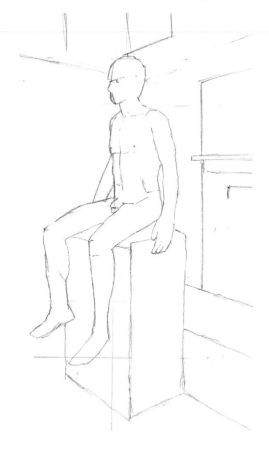

Two-point perspective

If you were to shift round to view the figure at an angle, so that the front of the figure is no longer parallel to your picture plane, you would be able to discern lines converging on two vanishing points. The model's knees below eye level are on an upwardly converging line, while the shoulders converge downwards. The plinth and lines within the room converge, albeit subtly, to two vanishing points. The eye level has remained constant.

Foreshortening

The challenge of drawing the foreshortened figure is one that all artists have struggled with at some point. The body in the foreshortened pose throws up strange perspectives and unusual aspects. At such times it is easy not to trust the eye and instead fall back on preconceptions about how things should look. The result of this is that the figure will be distorted or will appear incorrectly angled, as if floating.

There are two ways to deal with foreshortening: measuring and looking for negative shapes.

Comparative measurements of proportions and distances within the figure should prevent preconceptions clouding your vision, helping you correctly gauge the shortening of distances on the body as it projects away. It is important to keep your viewing position constant, since even slight changes will alter the degree of foreshortening, making comparisons difficult.

The second approach is to look for negative shapes around the figure, which are created between positive forms, such as the side of a model's leg in relation to the edge of a chair. Shapes are often easier to gauge than isolated lines. It is also useful to take a side view of the foreshortened body or limb, as seeing its full length can help you comprehend the degree of foreshortening.

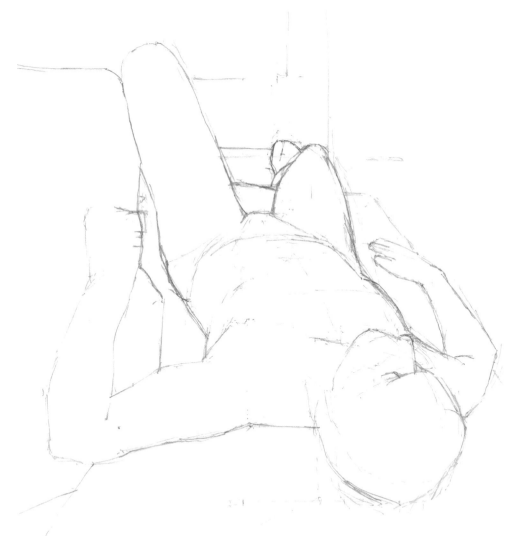

In this pose, the model had his head towards me to create a large degree of foreshortening. The first marks described the axis down his body – the imaginary centre line and the axis of the shoulder. I then took a vertical measurement of the head, from the lowest point where it contacted the bed, to the chin, and saw that the same distance upwards took me virtually to the knee-cap of the right leg. This is typical of the surprises that you get when preconceptions are swept aside by measurement.

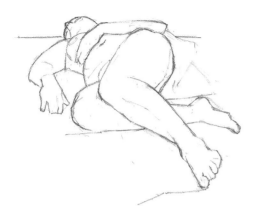

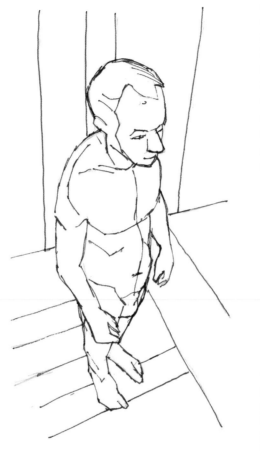

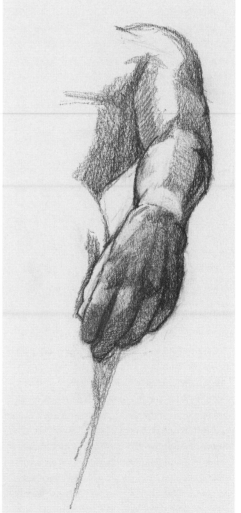

By using measurement I was able to gauge the effects of foreshortening on the arm of a plaster cast (below). The degree of foreshortening was quite staggering. The length of the hand, fingertips to wrist, was virtually equal to the distance from wrist to shoulder. While taking these measurements I also checked vertical alignments, noting that the little finger was directly below the apex of the shoulder. This helped me to gain the important angle of the arm. The final aid to understanding the degree of foreshortening was to look at the diamond-shaped negative space between arm and hip.

Using sight-sized measurement helped me deal with the extreme foreshortening in this pose (above). The legs – the closest part of the model to me – dominated the picture space, while the head was diminished in length, as measurement confirmed. The negative shape created between the arm, knee and torso was of great use in finding the shape and line of the arm and conveying its foreshortening. Without these ways of looking it would have been all too easy to lose the sense of connection between the model and the bed.

This unusual viewpoint was achieved by standing on a chair. The degree of foreshortening was fairly acute; measurement established that one head height down from the chin was the model's navel, while one head height more took me to his right foot. This unit of measurement also conveniently coincided with three floorboard widths when measured vertically, and so a smaller unit of measurement was also established. I had to trust these means and be aware of the vertical alignments of key elements through the body, as there was little negative space to go on. Another aspect of the pose that was fascinating was being able to see the emergence of the neck from the shoulder blades albeit in a foreshortened manner.

Measurement

Getting the scale and proportion of different parts of the body correct before you start drawing is very important. Using a few basic measurements, these issues can be dealt with and then more intuitive drawing can follow. Measurement will particularly help to deal with foreshortening on the body and limbs. When we are constructing the pictorial space, measurement is again vital and can help to incorporate the figure within this space.

When measuring it is important that you close one eye and use the same eye for all checking in order to avoid viewing discrepancies. Take particular care that you maintain the same viewing position, which may require you to mark the position of your feet on the studio floor. Your easel should be at arm's length and you should be able to view the model and your drawing in one easy eye movement. One common error is that students often mark the position of their easel and not their feet!

You may find measurement daunting at first, but it soon becomes second nature and will be seen as a useful tool. As your drawing progresses, you are likely to discover symmetries, rhythms and alignments in the figure and scene and you should make use of these.

The 'tool' most commonly used to take measurements is your pencil and thumb, but rulers and grids may also help in some situations. You can use your measurements in two ways: sight-sizing and comparative measurement.

Sight sizing

The measurement determined on your pencil, or by ruler or grid, may be transferred directly to paper without reference to other distances, which means that the image on the paper is the same size as the image your eye perceives. This simple and direct method is known as drawing sight-sized and is a good introduction to measurement. Sight sizing has one disadvantage: it limits the scale of the drawing, which may be found to be too small if the model is distant.

Comparative measurement

If you want to make the scene in your drawing larger or smaller than the size of the scene your eye perceives, you will need to use comparative measurement. This involves selecting a unit of measurement in the composition, such as the head, as the basis for estimating other distances. The head height is convenient as a unit of measurement because of its size relative to the rest of the body, and because the distance between many of the body's useful landmarks often coincides with head heights. You can also use half-heads, other parts of the body, or props as units of measurement.

TIP

Everybody has one eye stronger than the other and there's an easy way to find your best eye. In order to determine which is the stronger, hold your finger upright at a distance of about 40cm (16in) from you. Then, with both eyes open, place an object directly behind it. Close each eye in turn; with your strong eye your finger will not appear to move, but with your weak eye it will shift considerably in relation to the object.

Rule of thumb

The most basic and versatile measuring method uses pencil and thumb and can measure any distance in your composition. To measure the distance between two points, extend your arm fully and hold the pencil vertically. With one eye closed align the tip of the pencil with the upper point and the tip of your thumb with the lower one. In the case below, the distance between the eyes and a point on the model's chest is being measured and could now be used for sight sizing or comparative measurement.

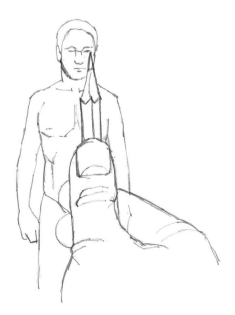

Using comparative measurement

First, you need to select a basic unit of measurement. In the sketch below, the head has been selected. To use this unit to measure the distance from head to toe, line up the tip of the pencil with the top of the head and the tip of the thumb with the bottom of the chin. Keeping your thumb in position on the pencil shaft, drop the arm until the pencil tip lines up with the bottom of the chin. Note the thumb's position against the body and repeat the process, counting the number of heads that the body measures. In this example, one head down from the chin is the centre of the chest and three landmarks on the body have been established, marked with dots. Once you have plotted the lowest point on the body, and marked other landmarks, such as extremeties, the navel and groin, it is a simple matter of deciding the scale and positioning of your figure in the drawing. As you will have only used dots at this stage, it is not difficult to change the scale or alter the placement of the figure.

Sight sizing landmarks

To sight size, plot key landmarks on to the paper using dots the same distance apart as the tip of your thumb and the pencil tip, as established when looking at the model (right). You should do very little drawing at this stage. Only when you are satisfied that these elements are correct should you begin to draw in features.

Sight-sized drawing

I measured the drawing below using sight sizing, and it became more intuitive once all the elements were plotted on to the paper. The advantage of sight-sized drawings is the speed at which they can progress.

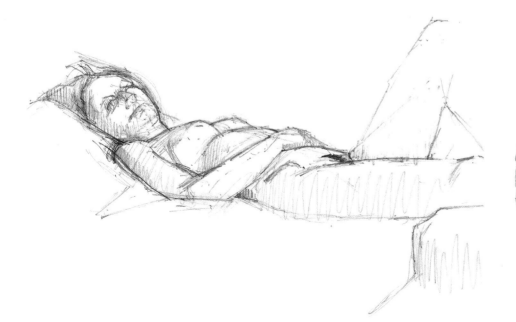

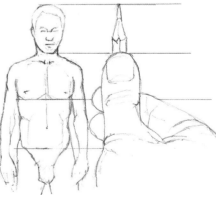

Landmarks

It is best not to start the drawing of actual shapes until you have plotted the extremities of the body along with some key central points, such as the gap between the clavicles, the navel and the groin, as you will find that some revision is necessary. Keeping your arm straight, you can turn the pencil to horizontal, and plot out from these centre points, hoping to reach further useful landmarks. If any of your measurements take you to any static elements around the figure, such as furniture, marks on the floor or wall, or light switches, then so much the better, as these can be very helpful. They also do not move!

There may be occasions when there is no suitable unit of measurement available on the figure, in which case you could select something static in the set-up, such as the distance between two points on an item of furniture.

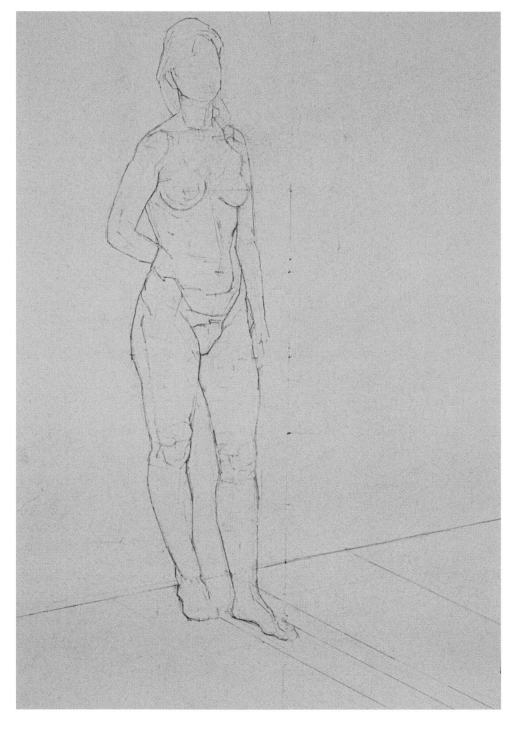

Standing nude

For this drawing I used the head as the unit of measurement, and it is possible to see the measurement marks on the vertical line in the centre of the drawing. Smaller distances were established using half-head heights and by comparing certain distances on the body with others. Sight sizing was rejected due to my distance from the model.

TIP

Look for the vertical halfway point on the figure; this is a good shortcut that will help with the placement of the figure on the paper.

If you view the subject through a grid held at close quarters (below), you can make alignments with key points on the body. You can then use divisions on the grid to measure and compare different distamces on the body. In this sketch, the grid shows that the distance from the model's eyes to her shoulder blades equals the distances between shoulder and breast and the top of the leg. Vertical and horizontal alignments of key features are also made apparent.

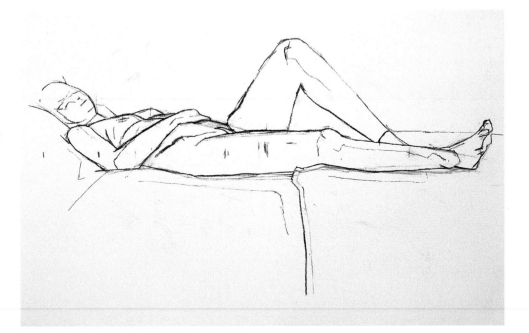

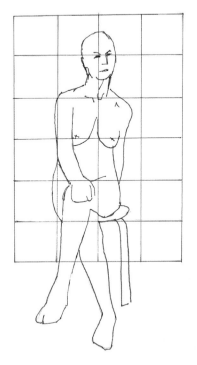

Rulers and grids

You can also use a ruler to take measurements, by holding the ruler at arm's length and viewing landmarks against its scale. This may be difficult, especially if you are shortsighted. Short rulers are also useful for establishing horizontals, which is done by balancing the ruler on your finger while pointing to the centre of your field of vision. This method is useful for checking the horizontal alignment of features on the body or in the set-up. You can also check verticals by holding the pencil by the tip and letting it swing until it comes to rest.

Grids can be useful in many ways, helping with measuring and checking alignment. They may also be used to aid composition when placing the figure and selecting boundaries. Care has to be taken with grids because problems may arise if the grid is not held truly vertically or not held perpendicular to your field of vision.

Subdividing the model

When the model is lying down it is not so easy to use head height as a unit of measurement. For this drawing I used thumb and pencil to locate the exact halfway point on the body. I found that the groin was exactly halfway between the end of the head and the tips of the toes. I then subdivided this distance and found that some of these points coincided with landmarks.

Tone

Tonal values are the gradations from light to dark seen on any solid object under the play of light. Differences in tonal values are sometimes termed intervals, similar to the intervals between musical notes in a scale. Observing tonal relationships between objects or parts of an object is one means of conveying a sense of structure. When building a pictorial space and creating a sense of context, tonal relationships are very useful.

Premixing tones

These five tonal values from white to black were pre-mixed with intervals spaced as evenly as possible. They were made carefully, using a palette knife. Achieving well-spaced intervals was more difficult than you might think. Such mixtures can be used as a framework for evaluating the values of the subject. Once the gradient is achieved, it is worth making enough of the mixtures to get your painting established.

TIP

To gain some practice in understanding tonal values, buy yourself a box of eggs. Open the lid and leave them in the box. They will offer similar challenges to those of the human form and the juxtaposition with the box is rather like that of props and furniture. Try several media and work in both day light and artificial light – you should gain valuable practice for the life room.

How to observe the subject

When observing a subject, the ability to read tonal values is hindered by colour, and it is helpful to find ways to edit out the colour information. A traditional method that works well is to half close the eyes so that the colour effects are diminished and tonal values are made simpler to read. In the past, artists also used to observe the virtually monochromatic reflection of a subject on black glass or tile; whatever the method, the aims are the same: to edit out colour information.

Rendering tone

Rendering tonal values requires materials that can produce a wide range of gradations from dark to light. Charcoal fits the bill, especially compressed charcoal with its wide tonal range. Graphite in all its forms offers flexibility due to the variety of its grades. Sepia ink and watercolour allow tone to be rendered sensitively in a way that is well suited to the human form. And gouache can create robust tonal paintings; its effects can also be changed as tonal relationships become more understood.

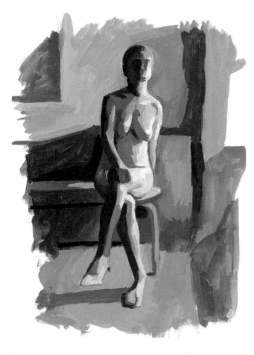

Premixed tonal painting

I started this painting (left) using the five pre-mixed tones opposite. There inevitably was some intermixing of tones as the painting took hold, but the discipline of working this way helped the painting to progress. It was not until several adjacent areas were painted that it was possible fully to read the relationships between tones and make necessary modifications, which is typical when working with tonal values. Another advantage of premixed tones is that their transitions are slightly hard-edged, which helps to construct a more solid figure.

Reductive tones

With a dramatic light source (below) my tendency is usually to make a high-contrast drawing that focuses on the intense light hitting the model's torso. But the amount of reflected light in the shadows, particularly on the model's legs, meant that more intermediate tones were needed. To begin, I covered the paper in a mid-tone into which the first marks were made with a kneadable eraser to bring out the lightest areas, such as the chest; no white was used in the drawing. Elements of the life room were also drawn, creating context.

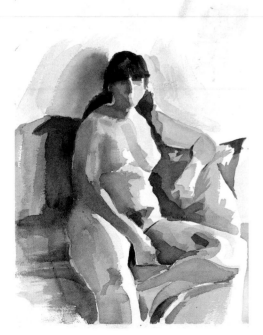

Sepia tones

Sepia ink is a good means of rendering tone; its slight warmth hints at the warmth of the sitter's flesh, especially in areas of shadow. The drawing was sketched in with pale sepia tones and built up over several layers.

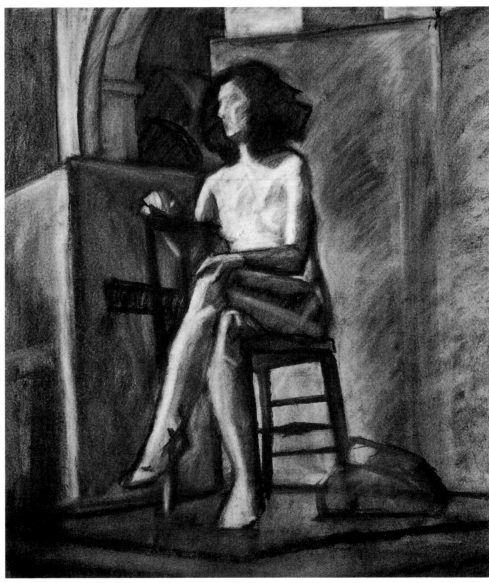

Drawing the head and face

The head and face most express the sense of the individual and it is the face in particular that sets each person apart. The skull is highly influential in this process since, unlike much of the rest of the body, the head is not covered with substantial layers of fat or muscle. Its structure is easy to discern and is of great help when drawing the features. Instead of drawing the outline of the head, which would tend to be somewhat arbitrary, you are likely to achieve better results if you consider the structures from which the head emerges and build up from these.

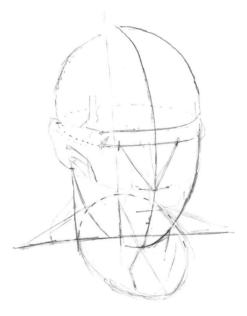

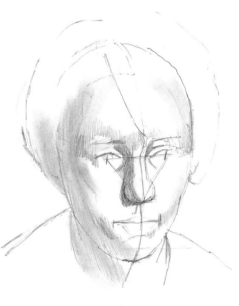

Blueprint for the head

This drawing began with the axes of the shoulders and spine, followed by an ellipse curving round from the spine to the gap between the clavicles. This gap, the suprasternal notch, is a key point from which you can trace a centre line that travels up through the face, head and scalp. The centre of the chin, mouth, tip of the nose and bridge of the nose all lie on this imaginary line.

From these central reference points you can find the head's outline. The axes of the eyes, base of the nose and mouth can now be plotted. I often use a broken line to continue them around the sides of the head in order to accentuate the three-dimensional qualities of the drawing. At this stage the drawing is provisional and subject to change, particularly the outline.

Building the features

Shading is introduced to help describe the head's form and the first attempts are made to sculpt the nose and establish the eyes and mouth.

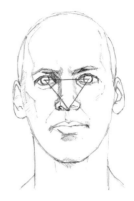

Front view of the head

The front view of the head underlines its symmetry and the proportional relationships of the features. A triangular relationship often becomes apparent between the eyes and a third, lower point. The location of this lower point varies; in some people it is the tip of the nose, in others the centre of the mouth. This person's third point is at the centre of the base of his nose.

Resolution

In the final stage I resolved the facial features and increased the density of shading, making it directional to convey the sweep of the forms of the head and face. I like to continue shading through into the hairline to retain a sense of the overall form of the head. Without this effect, the hair may look like an unrelated structure.

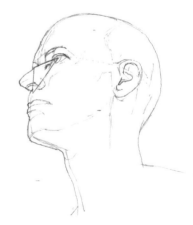

Three-quarter view of the head

From a three-quarter angle and viewed from slightly below, the proportional relationships of the features change. The shape of the triangle has altered dramatically, demonstrating the effects of perspective.

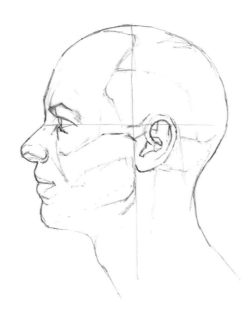

Side view of the head

In the side view we become aware of how small the face is in relation to the rest of the head. Useful landmarks emanate from the cheekbones; viewing and drawing these may aid the construction of a convincing profile. When drawing a profile I begin at the central point, in this case the junction of the ear and cheekbone.

Facial features

Although the face makes up a small part of the surface area of the head, it is the face to which we are drawn when attempting a likeness. It is important that the features are correctly positioned and successfully accommodated within the head. Establishing the axes of the features during the early stages of a drawing (see *pp.90–91*) lays down much of the groundwork.

The eyes are spheres set into the orbits of the skull. Although they are almost totally obscured, it helps when drawing to remember their spherical nature so that you can avoid them appearing flat and lifeless.

When drawing the nose, it helps to work from the bridge and to observe the angle of the front surface in relation to the face. From this point you should try to clearly establish the flat planes of the nose, even if the nose itself is rounded; by doing this you will create a convincing structure. Even from the front these planes are visible if you know where to look for them.

The mouth is one of the more difficult features to draw. In a front view it may appear to lack structure, and the colouration of the lips can prevent a sense of connection to neighbouring areas of the face.

Many students also experience difficulties with drawing the ears, but with practice and diligence the process becomes easier.

Side view of the eyes

From the side the eyes display their spherical nature as they emerge from the skull. Conveying this may add much interest to a profile drawing.

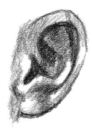

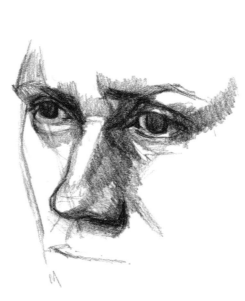

Three-quarter view of the face

The three-quarter view is a challenging one that defeats some. Being aware of the all-important triangle and centre line of the head (see pp.90–91) will help you to avoid the pitfalls, the biggest of which is being unaware of the need to reduce the width of the distant eye in relation to the nearer one.

Side and three-quarter views of the ear

The side view of the ear (top) shows the connections between its main elements. The lobe continues into the outer ridge, while the inner ridge curves round to meet the upper part of the lobe. Seeing these connections simplifies the drawing process. Shading has helped link the elements together. The three-quarter view (above) shows the outward projection of certain elements.

Front and three-quarter views of the mouth

In order to create a sense of connection between the mouth and adjoining areas, it helps to overlook the change in pigmentation from face to lips and read the underlying form (top). Here I have looked for shapes that create a continuity of form between mouth and face. A three-quarter view (above) shows how it has taken on the curved form of the underlying structure.

Nose viewed from below

This unusual, foreshortened view of the nose shows how it connects to the forms of the upper lip and to the forehead. Perspective across other facial features is also apparent.

Three-quarter view of the nose

This view shows the structure of the nose fully: the plane from the cheek to the bridge; the front plane from tip to bridge; and that of the underside. I find it useful to develop the overall structure before the nostrils.

Drawing the torso

The torso is the largest single structural component of the body. Its cylindrical structure is formed by the curvature of the ribcage. Its uppermost point is marked by the collarbones or shoulder blades, its lowest point by the pelvis. These points mark two useful axes for describing the body's attitude. The spine, which supports the torso, forms a useful vertical axis. These axes should be established at the outset in any drawing of the entire figure.

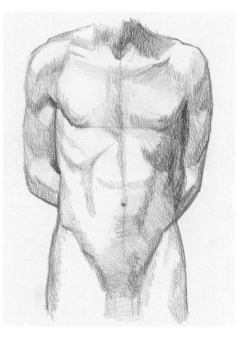

It is natural when drawing the figure to begin with the outline, but a greater understanding and better drawings will result by building from within. Here, the model is positioned high above eye level. The first stage was to find the main axes that demonstrate the body's angle and the effects of perspective: the vertical axis aligned with the spine and two horizontals marking the pelvis and shoulder blades, drawn in red. The pelvis tilts upward,

indicating that the nearer leg is the one bearing weight. Another line arcs round from the pelvis to the navel, conveying the torso's cylindrical quality. Establishing these axes is essential to conveying the three-dimensional aspect of the body: the centre line curving up the centre of the body marks the point beyond which the body starts to curve away and beyond which distances in relation to it diminish by comparison with those on the near side.

Viewing the torso from the front, you are immediately struck by the symmetry of its features. Any bend or tilt is easy to read from this angle. Key landmarks are the gap between the clavicles and from this gap a line through the central ridge of the sternum between the breasts, through the navel and into the groin. As the body turns, the shift in relationship between these points helps us to read the shape of the chest and abdomen.

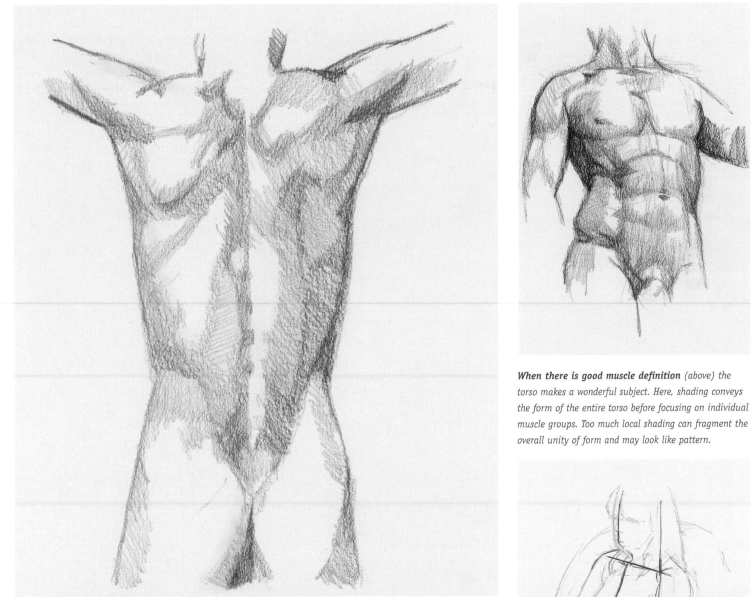

When there is good muscle definition (above) the torso makes a wonderful subject. Here, shading conveys the form of the entire torso before focusing on individual muscle groups. Too much local shading can fragment the overall unity of form and may look like pattern.

This rear aspect of the torso (above) shows the spine and shoulder blades. At the base of the spine the diamond-shaped sacrum can be seen. All these features will illlustrate in the simplest terms any bend or twist in the torso.

The red lines indicate the axes of spine, clavicles and breasts (right). From the clavicles a fourth line darts back to the neck and continues upwards to form the centre line of the face. This line also moves downwards from the clavicles to form the body's centre line. From these axes the journey to the outline could begin.

Drawing the limbs

Drawing the limbs well is vital to the success of all life drawings. The leg is split into two sections, above and below the knee, as is the arm above and below the elbow, and they can adopt many interesting and challenging positions: in a standing pose the issues of axis, shape and proportion come to light, but if the model is seated, kneeling or lying, foreshortening becomes an issue.

Strategies for drawing limbs

Measurement helps to determine the proportions of the leg and thigh. Using a unit of measurement, plot down from a key point within the body, such as the pelvis or shoulders, to some landmarks down the limb. Check the vertical alignment of landmarks, starting from a lower point, possibly the inner or outer anklebone or wrist, then repeat from an upper point. This will enable you to keep tracks on any curvature or tilt. Don't start to draw at this stage, just make marks that indicate the landmarks. Build from the inside and don't rush to find the outline.

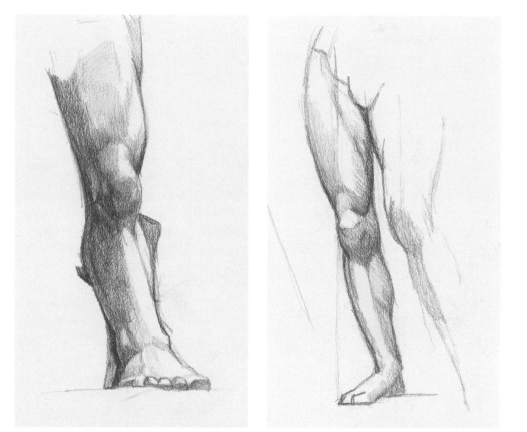

After I established the main axis of the leg, a horizontal measurement across the knee was turned to the vertical to determine proportions. Three of these units took me to the inner anklebone and upper thigh, respectively. Using my pencil as a plumb line, I found the inside of the knee was directly above the little toe – useful for determining the angle of this weight-bearing leg.

A second drawing of the same leg shows a vertical line connecting the middle of the upper thigh and little toe, again demonstrating the leg's tilt. It would be all too easy to overlook this and lose some of the drama of the pose. Shading helped describe the form and muscularity of the leg in both drawings; it also helped me to navigate my way around the leg and build a convincing structure.

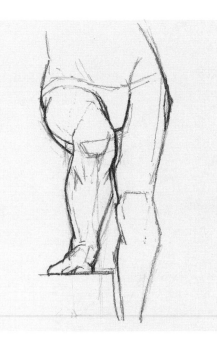

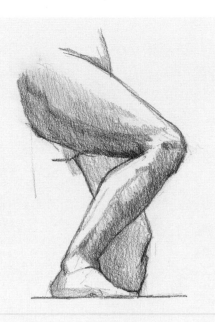

The challenge of drawing the foreshortened leg (far left) is in conveying its projection convincingly. In this case, knee width seemed a good unit of measurement and I made plottings from a sharp point at the base of the trapezium-shaped kneecap in all directions. One such point was the widening of the inner calf muscle. Another point, at the top of the thigh, was not an exact match but its short distance served to demonstrate the extent of the foreshortening. A vertical check showed that the centre of the kneecap was directly above the inner ankle. Finding negative shapes between the legs was the final tool that helped me draw the leg's foreshortened shape.

A second drawing of the same leg from the side helped put the foreshortening in context (left). The forward thrust of the knee and resulting angling back of the lower leg fully explains its short length in the previous drawing.

When the arm is bent it is helpful to establish points of connection and articulation in tandem with the main axes before the drawing becomes too established (right). This simple drawing began with the axes of the shoulders and front of the body, providing two larger forms to which the arms could relate. The completed drawing (bottom right) shows just how this way of looking can help. The muscle definition was again useful in giving structure and form to the arm.

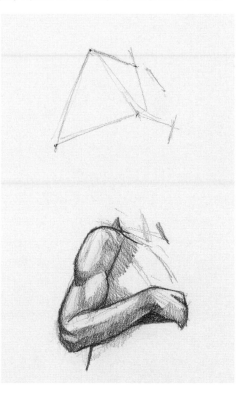

Drawing the arms raises the same issues as does drawing the legs, and establishing the main axes and determining proportion are vital. For this drawing (left) I followed a similar process as for the legs (above) and paying attention to negative shapes helped me find the arm's inner shape. Development of the outer shape of the arm was aided by an awareness of the shape and function of the brachioradial muscle.

Drawing hands and feet

It is important to draw hands and feet convincingly. Badly drawn feet do not connect properly with the floor and possibly not the with model's leg. Hands must appear functional. Fiddly, formless hands and feet reflect poor draughtsmanship because the language of their construction is often different to that of the rest of the drawing. The key to success is to look for geometry; it is often the simplest shapes that help to attain structure.

Hands can be difficult to draw convincingly due to their mobility and flexibility. It is the fingers that really cause problems; they are important but they have to be seen as part of the greater structure of the hand. The same basic rules apply to drawing the feet but because the foot is less mobile than the hand, it should in theory be easier to draw.

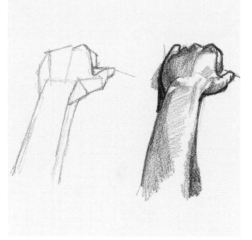

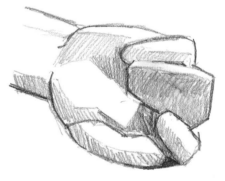

A good strategy for drawing hands is to identify their geometry. The arm on the left has been constructed like a length of square-cut timber, forcing me to fashion the hand as series of flat planes. The hand on the right was developed in the same way but taken through to a more finished state, demonstrating the value of simplification.

Curled fingers complicate matters. In most situations the fingers form into groups; it would be unusual for all four fingers to be separated. In this case the two middle fingers have grouped, enabling me to simplify the hand. As the drawing progresses it is easier to make alterations to a simple shape than to a complex one.

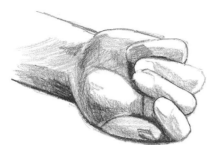

In this more realized version of the previous drawing, the two middle fingers, which started off as one block, are now distinctly separate. Interior shapes between the elements of the hand have helped in its construction.

TIP

Make drawings of your own hands and feet. The more time you spend studying them, the more confident you will become. Also copy the hands and feet of the old masters – they were dealing with the same issues.

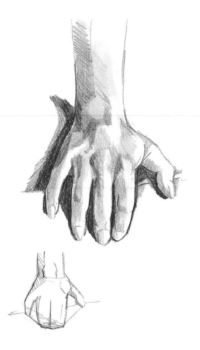

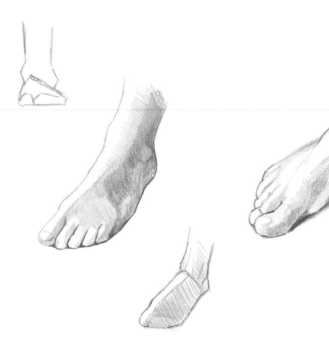

In the initial stages of this drawing, the splayed hand has a paddle shape, with imaginary lines connecting the fingertips and thumb. The central fingers are grouped, to be divided later. It is not always appropriate to develop the fingers, especially in small drawings; in such cases a simplified rendering is often more fitting.

The front view of the foot (top) presents a wedge-like cross-section; its highest point is over the arch. The outer edge (centre) makes almost complete contact with the ground along its full length. A simplified view (bottom) demonstrates the slope from the high point above the arch to the outer edge and is one way to begin a drawing of the foot.

The inner edge of the foot makes intermittent contact with the ground at the big toe, ball of the foot and heel, but the arch section is well clear of the ground (top). A simplified view (bottom) shows the high ridge above the arch with the points of contact clearly visible.

Using light

Light sources exert a strong influence on your ability to see your model and set-up and are often very influential in the making and appearance of the finished life drawing. Light and shadow are indicators of form and harnessing them will allow you to create the effect of three dimensions on the flat surface of the paper. The use of a dramatic light source may give a drawing impact and make the process of drawing exciting. And introducing an artificial light source may highlight previously overlooked issues.

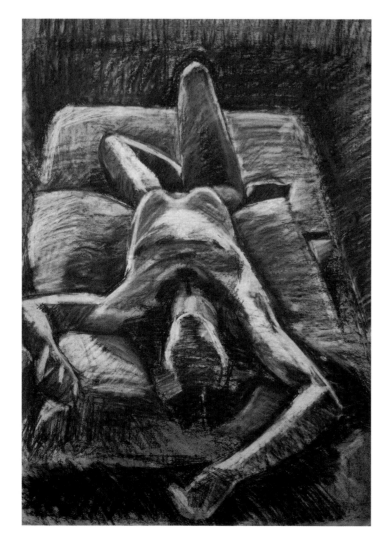

The way a figure is lit greatly affects how it presents itself to the artist. And differences in the position or the nature of the light source may dramatically alter the appearance of a set-up. Your position in relation to the model will also change the direction from which the light approaches the body.

Natural light tends to provide a softer and more diffused illumination of the body, with lower light contrast, and it also tends to make colour easier to ascertain. However, natural light changes, often in seconds. Artificial light can be trained on the model for dramatic and possibly unnatural effect; lights can be lighter, shadows deeper, helping us to read changes in planes more easily and give more of a sense of structure. Of course, artificial light allows us to continue working long after natural light has disappeared.

Natural light

Front lighting of the model may produce rather disappointing results. For example, if we are viewing the model with the light entering the

Dramatic lighting
This dramatic, naturally lit set-up suited a reductive drawing in compressed charcoal. The paper was covered in compressed charcoal to create a grey ground; the first marks were made using the eraser to seek out areas where the light was most intense. Darks were added with charcoal and mid-tones created by rubbing with cloths.

space from behind us, there is no modelling of form and the set-up will appear flat and shallow. However, if we are viewing the figure with light sweeping from left or right, the figure is modelled in light, form is emphasized, and volume and solidity are possible to translate into drawing.

With a sweeping light cascading across the set-up, the body appears monumental and statuesque and the scene may be very dramatic. When the figure is viewed against the light, no traces of detail on the body can be discerned, making the artist think instead about the body's shape and how it relates to its surroundings.

Artificial light

Front lighting of the model in artificial light results in the same flattening and reduction of form experienced in daylight. Artificial light gives more control over direction, providing more creative possibilities, allowing you to supply light above or below, effects that are difficult to achieve with natural light. This effectively means that that you can pose the model and then alter the light source until you have the degree of modelling that you require.

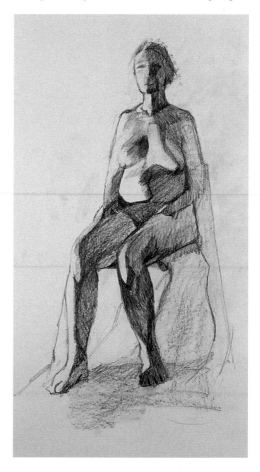

Harsh lighting

This seated nude was artificially lit from the left using a spotlight. As the light raked across the figure, it formed dramatic harsh shadows. Unusually, the shadow was most intense on the apex of forms, where the direction of planes changed. The drawing, made in graphite crayon, was kept hard-edged to enhance the dramatic lighting.

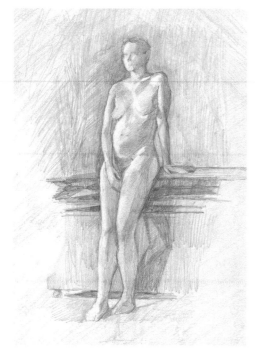

Sensitive lighting

For this reductive pencil drawing in natural light, I toned the paper with graphite crayon. Because graphite has lower contrast than does compressed charcoal, it has the potential to give a greater number of mid-tones, resulting in a more sensitive depiction of the play of light. I used different grades of pencil; soft grades for deepest shadows and harder grades for half-tones.

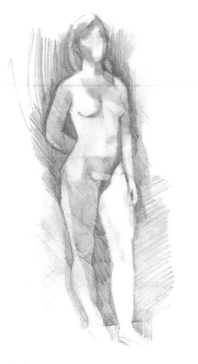

Deep shadows

In this naturally lit set-up the model appears to be emerging from the shadows on the wall. Avoiding the use of line at the outset, I began with the lighting concerns, drawing in the shadow as a block of tone. I then erased to bring the figure out of the shadow. Structure and pictorial space are often lost when shading becomes too local, so I looked for continuity of light and shadow.

Balance

At the moment that a body comes to rest, or the moment that the model adopts a pose, the body must establish equilibrium so that it does not fall over. Developing an awareness of where the centres of balance lie is vital in order to make your drawings convincing. Figures that lack balance will not appear rooted and may seem to be falling over. To establish the equilibrium of a figure in any given pose, you will need to determine the line of balance.

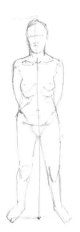

Symmetrical stance

The model is standing symmetrically with equal weight on both legs, and the gap between the clavicles is lining up vertically with the navel and groin. The line of balance runs from the clavicle gap to a point on the floor midway between the feet.

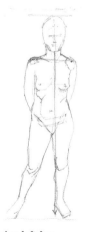

Weight-bearing left leg

If the model transfers weight to her left foot, the pelvis swings up to the left leg and pushes the hip outwards. The left shoulder dips to counterbalance this. The balance line runs from the clavicle gap to the inside left foot.

The front view

If the model stands symmetrically, with equal weight on both legs, the central points on the body should line up vertically, and the pelvis and shoulders should be horizontal. To determine the line of balance, you can use one of three central points on the upper body: the gap between the clavicles, the navel and the groin. If a plumb line was dropped from the clavicle gap, it would hit the floor midway between the feet. This is the line of balance.

If the model shifts weight on to the left leg, several things happen as the body rebalances. First, the pelvis swings up towards the weight-bearing leg, pushing the left hip outwards. The left clavicle positions itself above the weight-bearing leg and the left shoulder dips to counterbalance the hip's outward thrust. Muscles on the weight-bearing side tighten; their opposite equivalents relax.

The rear view

When viewing the body from behind, the story is similar but the space between the shoulder blades is used to determine the line of balance. There are several useful rear landmarks that indicate angles of tilt that the body may adopt: the shoulder blades, the spine and, at the base of the spine, the two dimples that indicate the rear of the pelvis.

The side view

When the body is observed from the side, the ear can be used to determine the line of balance, and lower points can be viewed in relation to it. If the model is standing upright, a line could be dropped from the ear through the knees to the arch of the foot. Matters change if the model takes a step forward and pauses. The weight transfers to the front foot, the ear lines up with the arch of the foot and the back arches slightly to stop the body from tipping forward and maintain balance.

Other poses

When the body is viewed at an angle, or if there is a twist in the pose, it pays to observe the angles of normally horizontal features and the vertical alignment of central ones. Note particularly the journey that the centre line takes as it travels down the body. It is also worth looking at balance in other types of pose, for example seated or kneeling poses in which the arm may be bearing weight.

TIP

By their nature, most poses that heighten the issues relating to balance tend to be uncomfortable. When exploring these issues in your drawings, therefore, you will need to work rapidly. This can be advantageous – a stick figure may say more about balance than a highly developed drawing.

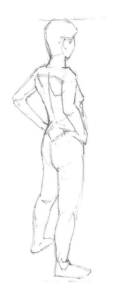

Off balance

Here the model's weight is supported by an easel, which she holds with her right hand. This lowers her shoulder and twists her torso around. The weight falls partially on her right leg, but were it not for the easel she would topple. In this respect it could be said that the figure is off balance.

Side and rear lines of balance

Looking at the model from a three-quarter angle, with her weight evenly distributed, you can see the side and rear lines of balance together. There is a slight forward tilt in the legs, which is counterbalanced by the arched back. The ear is in vertical alignment with the arch of the foot.

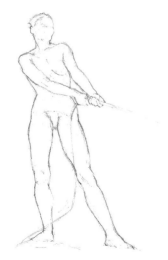

Twisting pose

This dynamic pose, seen from a low viewpoint, contains a twist in the upper torso. The weight is falling on the model's right leg, the right hip is pushed up and the right shoulder dips to counterbalance this. Despite all this, the clavicle gap aligns with the right foot.

TIP

Use yourself as the model and stand in front of a mirror. Observe the changes that occur as you shift weight from one side to the other or twist, but above all feel the changes in tension in your muscles.

Movement

Any study of the human figure is surely incomplete without some enquiry into movement. You might choose a subtle motion, such as the shift of weight that produces a change in balance, or a broader action, such as the model moving from one position to an entirely different one. You could also track a series of movements over several positions. Tracking changes during movement will give you a more complete picture of the human form and help you to avoid your drawn figures looking static or wooden.

Capturing the essence

When studying movement, the essence is more important than detail. It is about the bigger picture, the main axis of the body and limbs, and so it is not necessary to become bogged down in facial features and fingers; there are plenty of other opportunities to study those. Your first drawings need be no more than stick figures that deal with simple gestures of movement so as to form a basis upon which to build. By focusing on the bigger issues and keeping them simple, you can make the freezing of action more convincing.

Frozen movement

In this fairly rapid drawing, movement is frozen. The model was able hold the pose for roughly one minute before having to rest, so it was adopted several times in succession before the drawing could be completed. This is a situation in which photography could help by making the freezing of action more realistic.

TIP

Photography is sometimes useful for capturing the moving form. Degas employed photography to good effect for his drawings, but in general photographs tend not to provide us with the information on three-dimensional form that we need to model muscle movement. Both photography and video can be useful for freezing action and observing change in outline, but it is advisable not to rely on them too much.

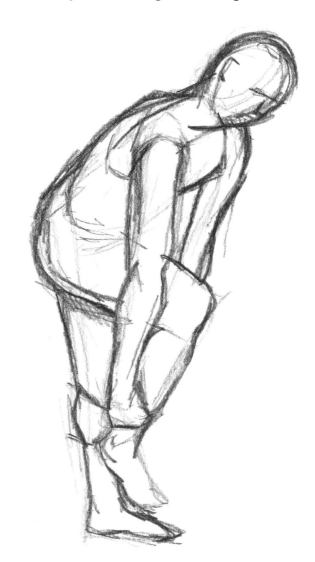

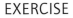
Repeated movement

An exercise that often produces interesting and valuable results is based on observing the same, repeated movement over a period of time. This allows the drawing to be built up slowly so that relative changes of the same points on the body can be observed and, if necessary, re-observed.

Panoramic movement is highly suitable for this exercise and involves the model taking several steps, each of which is held for roughly one minute. At the end of the run, the model returns to the first position and starts the sequence again. You need to be able to view the entire body, head to toe, and the full width of the model's progress.

If space is limited, you might observe a circular movement around a central object, but this means that the body will overlap itself a number of times. The solution to this problem is to draw each position in a different colour; the results tend to be very interesting. Movement within a static set-up is also useful and interesting to observe. The model can adopt several positions within a small environment.

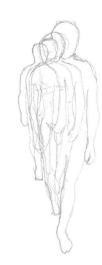

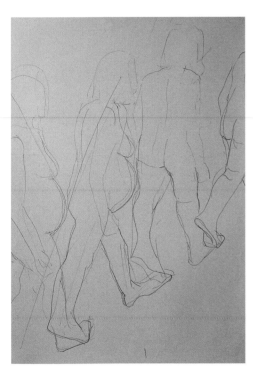

Repeated movement
It is fascinating to recreate a model's movement by returning to and drawing the same positions over a period of 30 minutes (right). Plot the positions of key points on the body as the movement progresses and pay attention to scale, making sure that the head does not get larger in proportion to the body if the figure is moving away. Begin with stick figures, gradually fleshing them out as the model returns to each position.

Panoramic movement
In this panoramic drawing (left), the model is walking both into and out of the area of the paper, which seems to heighten the sense of movement. The artist started by drawing the position of the feet, which themselves imply movement, and constructed upwards from them.

Overlapping figures
Some students will have a panoramic view of the model's progress but if the model is moving towards you (above), the various positions will overlap. Inexperienced students may find this position difficult to work from, but when the drawing works the result can be remarkable.

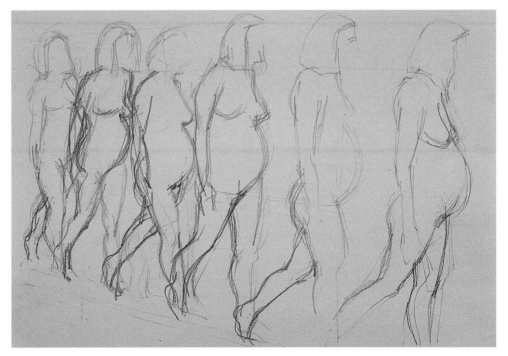

Storing and protecting your work

Work on paper is usually fragile and susceptible to mechanical damage and so should be carefully stored. One basic precaution that should always be taken is to label your work carefully using a non-caustic material – pencil is ideal. And it does no harm to dispose of weaker drawings as your skills improve. As the quantity of work increases, it is inevitable that some work will become damaged, and losing some of the weaker work should contribute to the safety of the better work.

Each work should be interleaved with glassine paper or acid-free tissue paper. Glassine is similar to tissue but has a glazed surface that does not cause any friction. Having used good permanent materials it would be a great pity to have them contaminated by the wrapping, so do not be tempted to skimp and use newsprint or brown paper for protection. Glassine or tissue paper will prevent pieces of work damaging each other or transferring their pigment to each other.

Portfolios
Portfolios must be large enough to accommodate the work entirely. Don't allow drawings to flap out of portfolios, which will lead to damage. The portfolio can be stored flat, possibly under the bed if space is at a premium. Acid-free card may be placed at regular intervals as markers and to prevent work bending when the portfolio is upright and being glanced through.

Mounting

Work that you deem to be particularly successful can be mounted for extra protection, which will also make it ready for sale. The best method is to have a hinged mount that opens rather like a book. Special acid-free tape is used for the hinges and to fix the drawing to the backing and it is advisable to used acid-free mount card. Masking tape, which contains acid, will cause severe yellowing of the drawing. Work that has gum strip still attached to it should have the edge trimmed to remove it; gum strip is not acid free and is sure to cause damage.

Protecting pastels

Pastel drawings are very susceptible to damage and so additional care should be taken with them. Pastels should be lightly fixed and stored between acid-free tissue or glassine paper. Always use a good brand of fixative and never use hairspray; this is designed for hair and does not used archival-quality ingredients. Beware of storing pastels in vinyl-sleeved portfolio systems, as static electricity may cause pastels and support to separate.

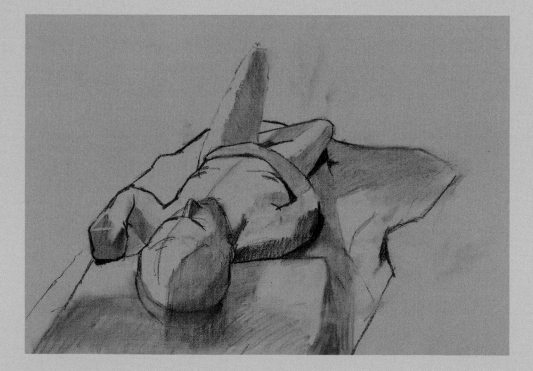

Masterclasses

Foreshortening

Figure on a Bed

Drawing the foreshortened figure is a challenge that I relish – perhaps it is the strange perspectives and distortions that this sort of pose produces that attracts me. Many students avoid positions in which they will be confronted by foreshortening of the body or of other elements – but in fact, an elongated pose is just as difficult only without the drama. This avoidance of the issue is often the result of an earlier failure but, as with most things, enough exposure to the challenge should eventually bring results.

Terracotta

Olive earth

Chocolate

Measurement is your single most important tool when dealing with foreshortening, since it forces you to trust your eyes and look hard at the subject, without resorting to preconceived notions about appearances. When drawing, it is important to let your eyes do the most of the work so your brain can process what you see. Measurements often emphasize the surprising size of certain close elements of the figure in relation to distant ones.

By comparing the proportions and distances within the figure, you can gauge the diminishing distances on the body as it projects away from you.

You can then start to look at the negative shapes around the figure, at the useful pockets between the forms of the body and between the body and other elements of the space. Shape can be more descriptive of what we see than line.

For this drawing, I decided to set a dramatic pose with extreme foreshortening by placing the model with her feet towards me, with one leg extended to create foreshortening and one raised with slight foreshortening of the foot.

There was an interesting display of form, particularly the nearest foot where I found the structure of the ankle very interesting. There were also interesting colours visible in the flesh that I wanted to hint at. For these reasons I decided to use coloured crayon to make the drawing, selecting terracotta for its fleshy qualities, olive green because I could see a lot of green in the shadows, and a dark brown to give depth to the deepest shadows.

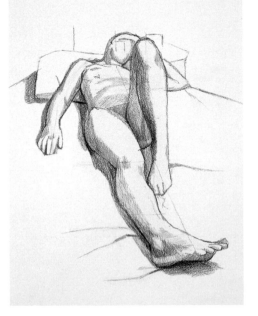

Techniques used

Measurement
Negative shapes
Line
Shading

1 | **First, I measured** the entire length of the body to find the halfway point, at a small depression in the outer knee. Using the pencil as a plumb line I determined that this point aligned on the vertical with the right side of the model's mouth. The heel on the closest foot also aligned with the centre of the upraised knee. These alignments were plotted.

A line drawn from the gap between the clavicles to the groin described the model's angle towards me. I then quartered the body length and plotted a shadow on the stomach halfway between the knee depression and the head. The line of the bed to the right of the model was then drawn; further measurement revealed a horizontal from where the right elbow met the bed to a rib. Looking slightly upward from this point, I was able to draw in the axis of the shoulders.

By looking at the horizontal from the depression in the knee and comparing it with the main axis of the body, I felt confident enough to draw in the axis of the hips. Finally I drew in a line that described the axis of the left arm, complete with its bend, and the position of fingertips was plotted. With the key elements in place I could now draw more intuitively.

2 | **Observing negative shapes** between the forms was the next stage; I was able to see three useful shapes in key positions. Towards the top of the figure were two triangles, one between the head and upraised knee and another formed by the torso, arm and edge of the pillow. Further down a triangular shape between the buttock, knee and lower section of upraised leg seemed useful. I really enjoy the qualities these types of shape bring to a drawing. With a little more measuring and by extending the shapes the figure started to grow. I often leave drawings at this stage because they describe the body in such unusual and subtle ways.

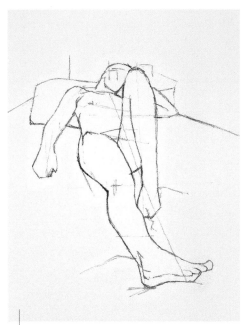

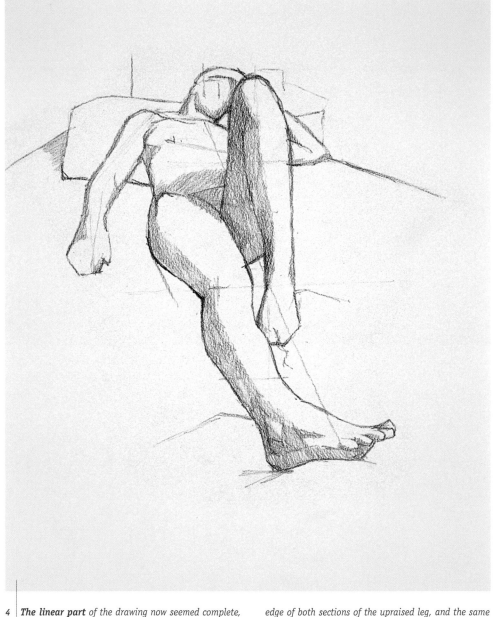

3 | **As the figure started to emerge**, sets of relationships, symmetries and rhythms helped the drawing gather pace – before long I had a figure that had begun to look human. As noted earlier, triangular relationships were particularly evident. Here you can see a further one formed by the hip, the apex of the shoulder and the point where the line of the chest disappears behind the upraised leg. Seeing such symmetries can only advance the drawing, as does the continuation of lines that may bisect a landmark or form another unassociated line, for example that of the inner arm continuing to form the line of the left side of the neck.

4 | **The linear part** of the drawing now seemed complete, so I began adding tone to convey the body's form, initially in terracotta. I was looking for broad continuity of tone rather than for its smaller facets. For example, a continuous tone covers the entire inner edge of both sections of the upraised leg, and the same is true of the outer edge of the other leg, from the hip to the underside of the foot. Observing such continuities gives a greater sense of structure to the figure. Local shading, by contrast, would tend to fragment form.

5 | *Olive green was introduced* to hint at the subtle changes in temperature, particularly in the shadows. This was effective for shadows on the bed and around the ankle area. I could see a slight greenish hue across the stomach, so the olive was also applied gently in this area. Where I felt that more contrast was needed, for example in deep shadow areas such as the underside of the foot and where the hip contacted the bed, the dark brown was highly effective.

6 | *This detail of the foot* shows perhaps the most dominant element of the figure; really rooting the heel to the surface was vital to the success of the drawing. The green provides an interesting cool contrast to the overall warmth of the surrounding areas, while the brown helps lift part of the foot off the bed by implying deep shadow.

Preparing for oils

A Head in Watercolours

I frequently add colour to drawings in order to complete paintings away from the subject at a later time and have tried this in the life room with some success. In a domestic situation, with more time and less pressure, you can make highly resolved coloured drawings, perhaps over several sessions. A friend and I have a long-standing reciprocal posing arrangement that has enabled us to make a number of drawings and paintings at a pace that suits us both. This time I decided that I would make a drawing with colour with a view to developing an oil painting in his absence.

Cadmium lemon yellow

Cadmium red

Alizarin crimson

Ultramarine blue

Prussian blue

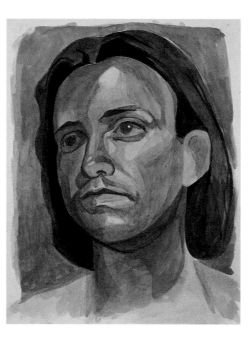

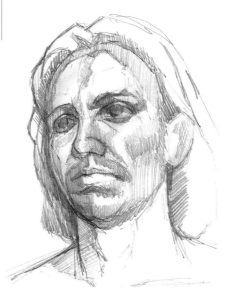

1 | *I made a rapid drawing in pencil to familiarize myself with the sitter – even if you are drawing a close friend there will always be something fresh to discover. Time spent on a drawing at this stage helps you absorb information about the subject and some decisions can be made about how the work will begin. A rapid drawing may also burn off some nervous energy before a more focused and sustained drawing is started. This drawing was made fairly quickly using soft pencil and employing a fairly loose form of hatching to sculpt out the main planes of the face.*

For this drawing my friend was posed on a chair while I sat on the floor, a watercolour block resting on my lap. With no easel, and watercolours or pencils to my side, this was an informal set-up. The colours chosen for the job were equally unfussy: cadmium yellow lemon would be my only yellow, cadmium red would be useful for warm areas of skin, and alizarin crimson would help create violets. I would use two blues, mainly ultramarine for its ability to create a vast range of violets, greens and greys frequently seen in flesh. Prussian blue would offer a greener alternative when needed. The idea behind the restricted nature of this palette was to give harmony to the colour mixtures; flesh is full of different hues and it is all too easy to lose harmony.

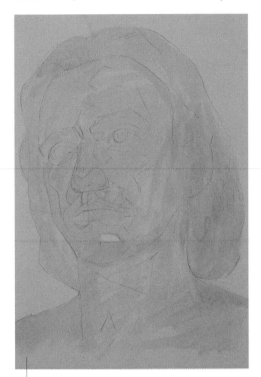

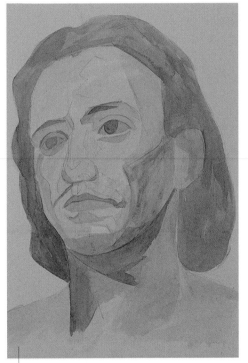

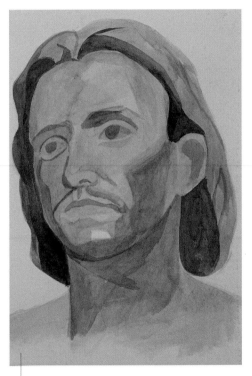

2 | *A second drawing was made on the watercolour paper block in HB pencil, because soft pencil may blend with any overlaid colour, leading to greyness in the mixtures. This linear drawing helped to position the main elements of the head and also the boundaries of some of the colour patches. The drawing was then over-washed with a very weak tint of pink, a dilute cadmium red and a highlight on the chin was reserved. This took away the glare of the white paper and introduced an initial element of skin tone to the drawing.*

3 | *Shadow under the chin was provided by a grey-green made from cadmium red, cadmium lemon yellow and Prussian blue, and this mix was also used for the hair and pupils. A violet was then mixed from cadmium red, ultramarine and a dash of lemon, to add work on the right cheek, ear and eye socket. A crimson wash was glazed over the bottom and top lips to bring in some cool elements in a so far warm palette. At this stage the head still looks flat and unresolved.*

4 | *To add more colour, I looked for areas where I could apply more intense washes, such as the forehead, where I applied a neat wash of cadmium red, and the near side of the nose, where an orange mixed from cadmium red and yellow was glazed. On the shadow side of the face, a glaze of alizarin-based violet was applied, contrasting with the warmth of the near side. Returning to the eyes and hair, an olive green mixed using alizarin crimson, yellow and ultramarine was painted in before a glaze of cadmium red was passed over the entire face, helping to unify what had previously looked cool and fragmented.*

6 ***To give the work more bite***, *I added some water-soluble coloured crayon around the mouth; adding water further enlivened the work. Modifications were made to the forehead's outline, which had been badly drawn; some hatched, dry, coloured crayon was used to give more structure, particularly to the mouth and chin. I took the drawing to a mirror and noticed that the neck was too wide on the far side, connecting badly to the* face. *To rectify this I moistened the area, waiting a minute or so before gently scrubbing the pigment away using a bristle oil-painting brush; high-quality cotton-rag paper permits such alterations. Once the area had dried, the necessary changes were made and under the mirror's scrutiny the alteration had worked. As a finishing touch I added a glint of light to the near eye, which I would do only if the glint were actually there.*

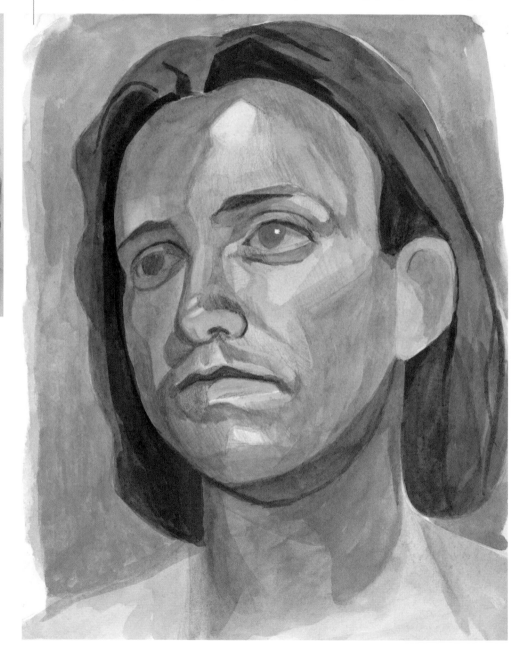

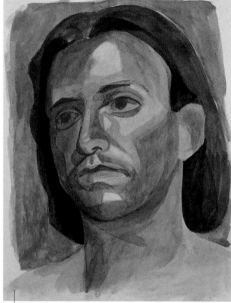

5 ***More cadmium red*** *was glazed on the forehead; a violet glaze was applied on the shadow side of the face; and a weaker form of this glaze was passed over the top and bottom lids of the nearest eye. At last, a glaze of cadmium red passed over the near cheek and side of the nose suddenly brought the drawing to life. Meanwhile a neutral khaki was painted into the background, and seemed to make the flesh colours work harder. Another orange glaze was used to intensify the nose area and an earthy orange, still made from primaries, was passed over the forehead.*

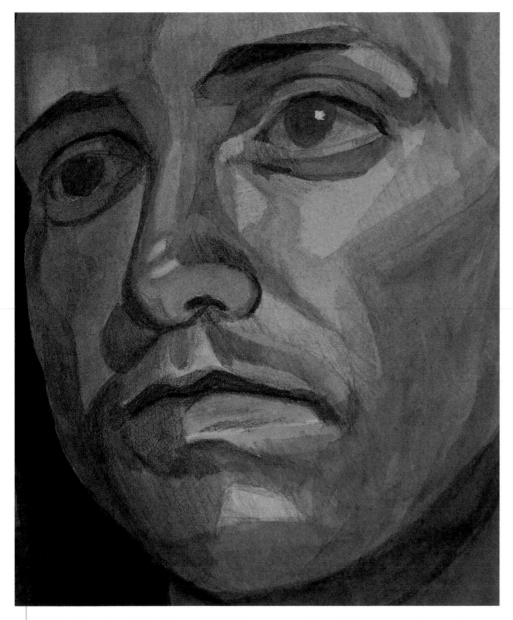

Techniques list

Line drawing
Wash
Reserving
Coloured crayon
Hatching

7 | **This detail shows** how the introduction of hatching in coloured crayon has added some structure to the centre of the face, particularly around the chin and the left-hand side of the lower lip. The shadow spans both areas, helping them to connect; I felt this was appropriate as both areas were on the same plane. Such decisions tend to strengthen the structure of the face. The introduction of a dry material also brings some precision back into the proceedings.

Using negative shapes

Two Figures

When two models pose together a life class may be enlivened as the scope for different ways of looking increases. Two figures will relate to each other in many ways but it is perhaps the spatial relationships that are of most interest to the artist. One interesting way of approaching this situation is to look at the negative shapes created by the space between the figures, or between the figures and the architecture of the room, as a way of creating pictorial space in the drawing. For this set-up, a female model was posed on a stool, which is positioned upon a plinth. Beside her a male model sits upon the plinth, legs dangling over the edge.

To make this drawing the artist has positioned himself where there is an interesting overlap between the figures, leading them to appear almost as one shape. The female model dominates the picture space, almost obscuring the male figure. To the outsider this may seem to close doors on a more interesting view of the pair but it can be refreshing to avoid going down the obvious route because unexpected rewards may be gained from a more unorthodox view of a set-up. The drawing commenced by organizing the picture space making sure that best use was made of the paper and that the models were positioned exactly where the artist wished.

Normally with two models this is a major issue but due to the compact nature of this set-up the main area of concern was the dominant figure. It was decided that she would occupy the upper portion of the paper, giving plenty of space for the spectator's eye to travel through before reaching the figure. This also helped to convey the fact that the figure was posed relatively high up on the plinth.

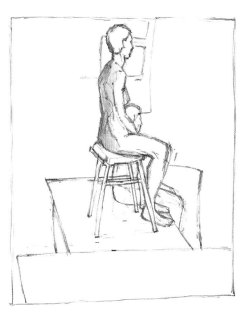

TIP

When drawing what appears to be an isolated model, try and seek out any elements, however distant, that relate the model to the space. Varying the weight of the line will help place the shapes in their correct position in the space of the drawing. Experiment with different formats on your paper and consider the entire picture space, right into its corners.

2 | ***Certain elements of the space*** *and figures conveniently lined up with many of the vertical plottings, helping the drawing to progress rapidly. Horizontal measurements were introduced, leading to points at useful pockets of negative shapes and helping to marry the forms of the figures to the rest of the space. For example, the triangle created by the model's leg and the stool.*

The internal shapes of the stool itself were another related group of shapes, but perhaps most interesting and useful for the process was the shape created by the model's head against the distant window. This shape was viewed as a complete one; rather than attempting to draw the model's profile first, the entire shape was drawn in one action.

1 | ***To aid the drawing's organization***, *vertical measurements were taken, using the head length of the female model as the basic unit of measurement. A vertical was established that ran from her eye to the plinth, and this was used to align the upper elements of the figure and room with lower points on her body and elements of the set-up. Seven head lengths down was the edge of the plinth; at three lengths was the centre of the stomach. So it was determined that the figure could be accommodated within the planned area of the drawing.*

At this stage an artist should be considering where key elements go and not doing much drawing. The danger of getting too involved at this stage is that certain elements could be fully developed but in the wrong place; the natural inclination when this happens is to accept the errors to the detriment of the drawing. It is easier to make alterations to simple marks than to highly developed features.

3 | ***It is easier to determine*** *the dimensions of a shape than the dimensions of an isolated line, both in terms of length and direction. Compare a shape with a section of one of its boundary lines. If the line as part of the shape is not correct, the shape as a whole will* be altered and the flaw will be easier to spot than a flaw in the isolated line. This is illustrated by the detail of the model's profile (above left), which is easier to gauge as a complete shape. On the right is a section of the profile, which is more difficult to draw in isolation.

4 | **The anatomy of the main figure** now drew attention, as the shoulder blades and spine were lightly sketched in. Some of the structures to which the figures were linked were also given consideration, and so the edge of the plinth was fully drawn. The second figure was now beginning to emerge and engage with the space and main figure.

The main figure's eyes were positioned too high in the head and so were corrected at this point. Some boundaries at the edge of planes were hinted at with line, such as the area around the model's hip, in preparation for some shading. | 5

6 | **The completed drawing** has acquired more solidity and authority in the quality of line, where the artist returned to and reaffirmed some of the internal shapes. Some shading was introduced on the back of the main figure to create solidity by subtly implying light and shadow. At this late stage, measurements revealed that the legs of the main figure needed to be made longer and that the bottom of the second figure was too low, implying that it was much nearer to the main figure than was the case. Moving it up placed the figure further away, which was the desired result. With these changes, the figures related to each other more successfully. As a final statement the artist drew a frame around the drawing to give an edge to the pictorial space and to impose the desired format on the drawing. The shape of the paper need not dictate this.

Techniques used

Measuring
Negative shapes
Line
Hatching and smudging

Working with watercolour

Against the Light

For this drawing, the strong light entering the room and bathing it with a violet glow on a beautiful winter's day demanded that I pose the model near the window. Because the light was so strong and directional, I lowered the blind sufficiently to keep her reasonably dark and also to enable me to see. The challenge of working contre jour, against the light, is an interesting one that most artists have worked with.

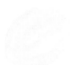

Cadmium yellow lemon

Raw sienna

Alizarin crimson

Burnt sienna

Ultramarine blue

Prussian blue

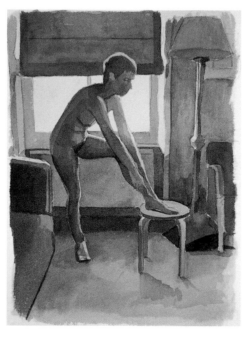

Once the body was posed, my first impression was that it seemed flat and silhouetted. However, the more I looked, the more I was able to discern a wide variety of colours in the shadows. It is on such nuances that the success of this type of painting works. The colours varied in temperature, with violet tendencies sitting next to yellows with little difference in tonal values between them.

Choice of palette

Usually I base my selection around primary colours, backed up occasionally with yellow ochre and an earth red, but the nature of the colours I could see in this subject made me feel that it needed more rich and earthy colours. The palette I chose was based on having the most transparent colours that could be continually overlaid without becoming muddy.

I selected cadmium yellow lemon for its sharpness, although I eventually found that it was used in only one area of the painting. Raw sienna was used as the main yellow, rich enough to bring warmth but transparent enough to keep the layers clean. Burnt sienna was used as the main red; in weak washes it can create the most perfect flesh colours, and used more strongly it has an earthy richness that produces good browns.

Alizarin crimson works well in combination with the both raw and burnt sienna two colours to bring in a cool clarity to mixtures and it also makes piercing violets. Ultramarine would always be in my range of colours, making greys and even blacks in combination with burnt sienna, violets with alizarin, greens with raw sienna and on its own a range of blues of all temperatures.

Prussian blue completes the selection for its ability to produce useful cool greens and greys.

My support was a cold-pressed 640gsm paper that was heavy enough to be worked on without being stretched. There would be no need for a drawing board for the same reason.

1 | **I began by drawing out** the figure and dominant shapes of the space in HB pencil – it would be useful to have the drawing remaining visible until I had made considerable inroads into the painting. Next I applied a weak alizarin crimson wash over the drawing, covering the entire surface; I did this because I could almost sense the colour in the light cascading through the window. The wash needed time to dry.

2 | **Using burnt sienna**, I began putting down the first layers of the figure and the blind and beside these a mixture of ultramarine and burnt sienna for the areas surrounding the window. While doing this area, I reserved areas of the paper that would receive little or no more colour. These were the window and parts of the frame, the stool, which would need to be almost as bright as the window, and highlights on the figure – on the arms and legs and the halo around the hair area.

3 | **Further layering increased** the depth of tone and colour needed to make the piece work. To intensify the body, I added alizarin crimson to burnt sienna and applied to the whole body except for the highlights. A wash of raw sienna was applied over the entire carpet area and burnt sienna and alizarin to the edges of the blind, where they needed to be darker. By layering I increased the depth of tone on the wall using the previous mixture of ultramarine and burnt sienna. Ultramarine was laid in for an item of clothing on floor and a mixture of alizarin crimson and burnt sienna was applied to the sofa. At this stage I was starting to construct the standard lamp with raw sienna for the shade and burnt sienna for the stem.

Techniques used

Line
Wash
Reserving

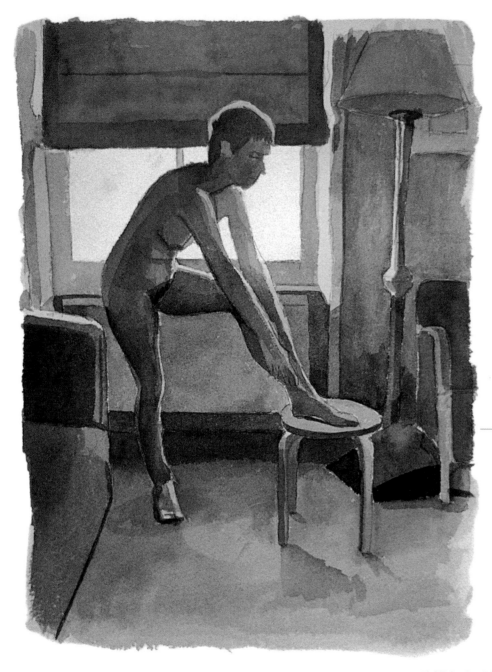

4 *A wash of alizarin crimson* was applied down the left leg because it looked cooler than the rest of figure; the process was repeated the raised leg. Further down on the stool, a small area of shadow was painted in to construct the arch of the foot. On the top surface of the standing foot, a glaze of violet was painted in and brought an interesting cool contrast the area. Violet reflected light on the upper left side of the foot does the same. Such small touches are what can enliven work carried out against the light, preventing it looking monochromatic and monotonous.

Sensing warmth in the light on the left portion of figure's back, I applied a wash of raw sienna and, once this was dry, a swathe of burnt sienna darkened and contrasted the area to the right of it, conveying a sense of light sweeping across the back. An alizarin and blue wash was applied over darker areas of the sofa and further washes of ultramarine and burnt sienna over the wall and across lamp, except for highlight on left side of the stem. The next layer on the lamp was raw sienna over the lampshade and stem. Putting same wash over adjacent elements helps tie them together and unify the piece. Treating elements separately does the opposite and fragments it.

Highlight detail
This image shows the area of the drawing with which I was most pleased. The foot and hand link up well with the highlights on the arms and leg. The juxtaposition of these elements with the background, particularly the light hitting the side of the window, worked well.

At this stage I was not satisfied that the left leg worked, so I sponged away some pigment around the inner ankle bone. When the section had dried, I redrew it using a brown wash to throw the inner leg into sharp contrast. The outer part of the leg was also sponged away, allowing me to rework and intensify the violet reflected light. The toes on the standing foot were repainted and these changes helped root the figure to the floor. The suggestion of a pattern was added to the sofa using alizarin and ultramarine, without drawing attention to it. The wall was darkened further to heighten the sense of light cascading through window. The hair and face were darkened and raw sienna was glazed over the halo of the hair. Careful painting in of alizarin crimson, ultramarine and burnt sienna created the fingers. The final act was some sponging away on a portion of the model's back and around her chin to give a sense of the light bleeding round the forms.

5

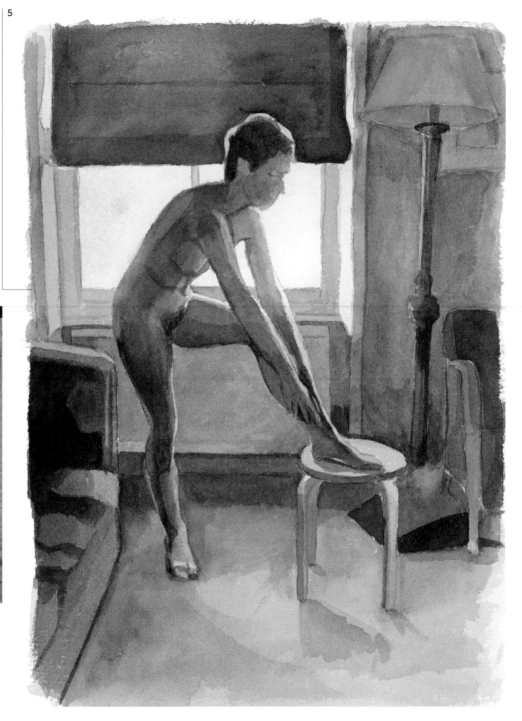

Halo detail
Reserving until the last minute helped create the halo of light around the model's head. You can also see the effect of sponging away around the chin. I was pleased with how the highlight on top of the leg and the light travelling across the stomach worked.

The body as landscape

Reclining Nude

Dealing with the complexities of drawing the human form can be daunting, even for an experienced artist. A useful exercise is to regard the body as a landscape and treat the various features as landmarks within it. The advantage of this approach is that it will help you to leave behind any preconceptions you might have about the body and its features, and force your eyes to work even harder.

Charcoal and white chalk on grey paper

The model was positioned with her head close to me and so I was looking down on a dramatic foreshortened view of the body. A directional light illuminated the body and the shadows helped reveal its form. The unusual and unfamiliar aspect of the body made it difficult for me to fall back into drawing what I thought I could see and forced me to concentrate more fully on the network of shapes that form the body. In such a situation it is necessary to forget about anatomy and instead get involved with drawing shapes and planes. We should try to view the body in the same way that we may see a newly encountered landscape, making a note of what is flat and where gradients change. It may even help to imagine taking a walk in this landscape or to think about how it would appear on a map complete with contour lines; this lack of familiarity can help you to see the body afresh. The lighting suggested that I should opt for a neutral grey mid-toned paper that would be more sympathetic to letting the drawing gradually accrue. As this grey represented much of the tonality viewed across the body, darks and lights could be added either side of this mid-tone to give a three-dimensional quality to the forms.

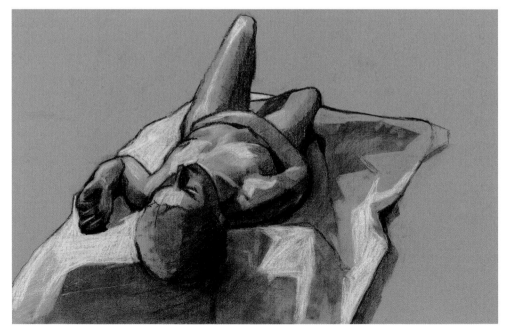

TIP

During the early stages of the drawing ignore local differences in tone, such as the hair, and try to use shading to construct form, establishing broader areas of tone before getting involved in smaller ones. Too much focus on local tone will tend to give a disjointed appearance to the drawing akin to surface pattern or camouflage.

First marks | 1

Using willow charcoal, I plotted a linear drawing on to the paper. Charcoal is useful at this early stage of a drawing, because it allows you to make changes without the need for an eraser. I established the key axes of the centre line and of the shoulders, breasts and hips, and used measurements to plot the positions of the arms, legs and other important landmarks. Inaccuracies at this stage could result in the angle of the body being incorrect.

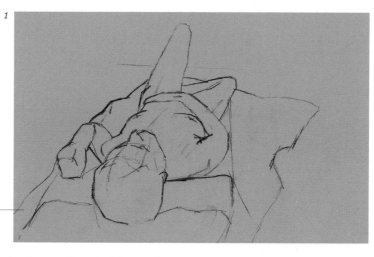

Adding tone | 2

Continuing with the charcoal, I added shading to give structure and develop the three-dimensional quality of the body-landscape, using two depths of tone over the mid-tone of the grey paper. I treated the model's hair as an extension of the head rather than as a separate entity. The same is true of the shadows on the sheets, which link with the figure and give an overall sense of solidity.

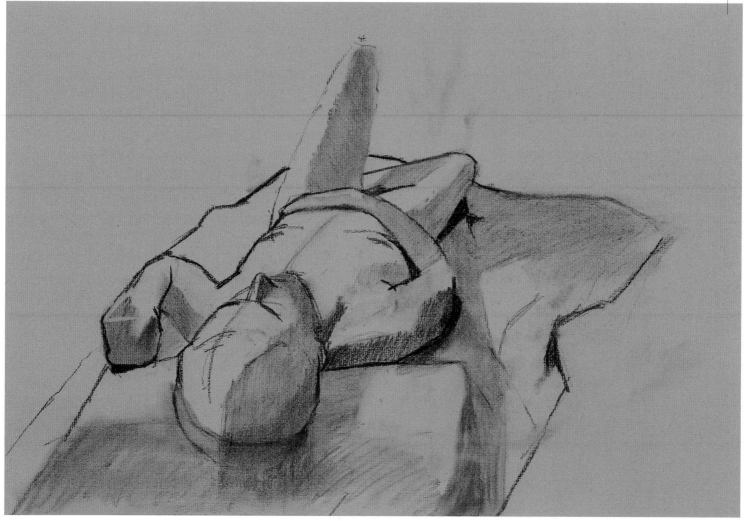

3 | **Creating shapes and planes**

Using white chalk pencil, I drew a zigzag of light on the right shoulder. Internal shapes such as this help to construct the body convincingly. I also added negative shapes, such as the patch of white between the head, hand and arm, which helps to deal with the fore-shortening and recession of the arm. To give more definite transitions of form, I avoided blending the tones too much, allowing the body to be viewed as a series of planes. This can be seen on the right shoulder, which has some hard edges. The structure of this area is reinforced with a combination of white chalk and heavier shading in charcoal pencil to give a sense of three planes turning away from the light source. The same is true of both legs, which I found could be summed up in three tones. Too much blending may deprive important areas of structure.

Finishing a drawing often involves tidying up, editing superfluous marks to add strength to the structure. This process should be seen as getting to the essence of the drawing – sometimes less is more. One of the lightest areas of the drawing is the sheet around the figure, which helped relate the figure to its surroundings, placing it in a context.

A previous encounter

The inspiration for treating the body as landscape came from an earlier drawing of a female head in which I tried to leave behind any prior knowledge of the face. The drawing came about as the result of problems that arose when I was doing a large-scale life painting. I was having extreme difficulty in painting the model's head, in terms of both drawing and tonality. It really hinged around the difficulty in understanding the head's structure when confronted by it at an unusual angle. Whenever I struggle with a painting I always turn to drawing to try and find solutions.

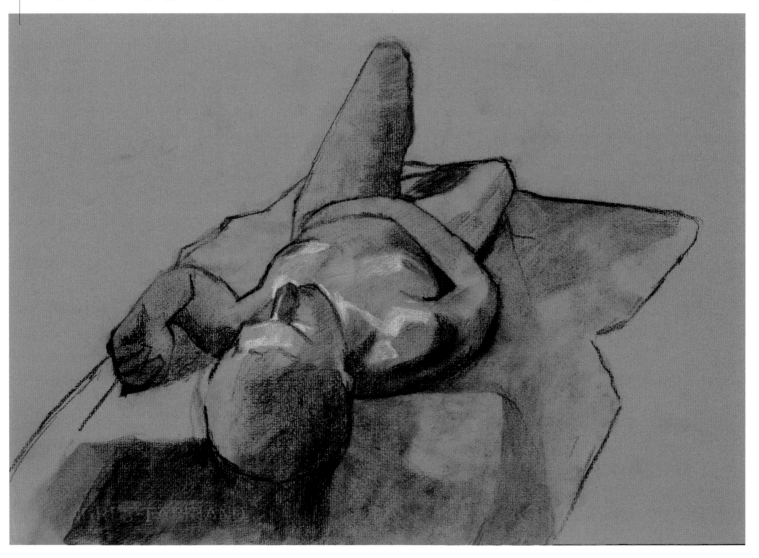

128

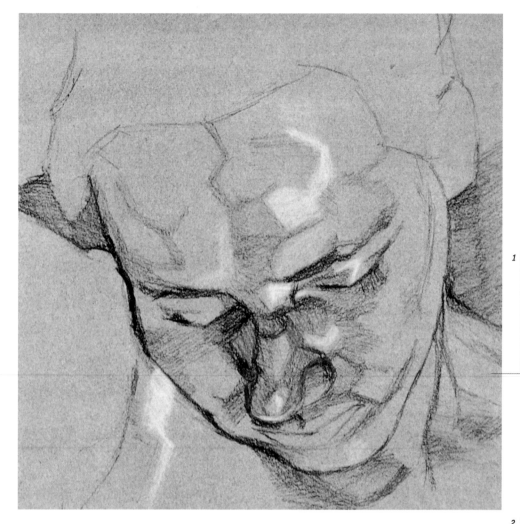

Sleeping head

Techniques used

Mid-toned ground
Measurement
Proportion
Line
Shading
Heightening with white
Foreshortening
Negative space

TIP

You should guard against adding too many small and unconnected areas of light or shadow within the figure as they can cause form to fragment.

1 | **To make the drawing** *I decided to use charcoal pencil and white chalk over a grey ground. I didn't have grey paper, so I made my own by stretching cartridge paper and laying down a watercolour wash made with a mixture of colours that created a neutral grey. This grey would be the dominant feature in the drawing and tones either side of it would be used to gradually construct the head.*

2 | **Rather than using measurement**, *which would have been difficult because I was so close to the model, I focused upon an area of the head from which the drawing could spread. The bridge of the nose seemed to be a good central point at which to start at and I positioned this just above centre on the paper. This was to allow for some pictorial space to accommodate the sweep of the shoulder. I oriented my way around the head by looking at shapes and how they fitted together to form the planes that built the head's structure. Some of these shapes were created by adding darker tones to the grey, and others were additions of light using chalk. I enjoyed drawing these shapes, especially on the forehead and found them as fascinating as the facial features. Eventually the various shapes connected to form a convincing head.*

Harnessing space

Figure and Pattern

Occasionally you might arrange a model in a pose that makes you stand back and look at the figure in a different way. This was the case during a summer school I was teaching, when a very challenging pose involving issues about the figure's relationship with the surroundings was set up which kept the students well and truly occupied for a number of days.

The set-up had the model posed on a stool against a cloth backdrop marked with a heavy pattern of repeated large circles. The first impression was of visual confusion. However, while drawing, colour information would be edited out and much of the perceived confusion would be removed. The figure seen against this pattern created interesting external shapes capable of guiding the students towards constructing the figure and space together, breaking down the notion of subject and background that deprives so many drawings of their sense of space. Under normal circumstances students would tend to concentrate exclusively on the model and neglect the surroundings, but with such a positive motif surrounding the model they would be forced into considering both with equal measure. This way of working could make for a very intriguing set of drawings.

Viewing the set-up

The positioning of the easel is important, especially with such a complex subject. You should be able to see the subject and drawing using minimal movement, so that shapes and angles are still fresh in the eye as you turn to your drawing. It is also a good idea to mark the position of your feet to ensure that your view is consistent. The student making this drawing was viewing the set-up with the picture plane at an angle of approximately 45 degrees to the wall. This would present a number of interesting problems to solve during the course of the drawing, chiefly the foreshortening of parts of the figure besides the set-up as a whole.

TIP

Always try to find your eye level when working with complex set-ups, as being aware of perspective helps to create a more convincing sense of space. Your eye level is at the height where any known horizontal line neither rises nor falls but remains completely level.

1 | **The drawing began** with the establishment of a useful vertical that bisected the centre of one column of circles; the first marks that plotted the rims of the circles at these points were made. The student used a steel ruler held at arm's length to take vertical and horizontal measurements. The scale on the ruler was read against the distance being measured, just like taking a measurement off a flat surface, and was scaled up using a simple ratio, in this case doubling. The ruler was also used to establish the picture plane by determining a horizontal. This was done by balancing the ruler across the knuckles while pointing to the centre of the set-up. By having a known horizontal it is possible to judge angles of recession, such as the angle of the floor, caused by the effects of perspective in relation to the horizontal. The eye level, which coincided with the model's neck, was also noted. This was indicated by the level nature of the pattern where it bisected her neck. Awareness of your eye level helps you to note the rise or fall of the lines of the architecture of the room and the model. In this case the effects of perspective on the pattern were also revealed.

2 | **A circle near to the model's** shoulder was selected and would help to find an approach to drawing the model herself. While doing this the student realized that he was viewing slightly elliptical shapes rather than circles, a fact backed up by taking a horizontal measurement with the ruler held parallel to the picture plane. He realized that because he was viewing them from an angle, their width would be narrower. Against the established vertical, a segment of the circle was drawn forging an important link to the outer edge of the model's arm and beyond it the shoulder.

4 | The student noted how the circles became narrower as they receded, a form of foreshortening. He had not considered this until measurement uncovered this fact. The drawing progressed well by further developing the figure, and other elements of the space such as the seat were drawn more fully, aided by looking at negative shapes. The angle of recession of the chair legs was determined by comparing them with the horizontal. Minor adjustments were made on the arm, which was too bulbous, and on the curvature of the circles. The series of shapes created by the circles, the chair and figure meshed together, helping the student achieve very convincing foreshortening of the arm, leg and foot.

3 | **The combined approach** of measurement and looking at the shapes created by the interaction of the model and circles produced a figure that was starting to emerge as a negative shape almost overwhelmed by the surrounding patterns. The student found this intriguing, and what had initially seemed a daunting task became an enjoyable experience. Finding new ways of viewing the figure keeps the process fresh and at such moments of inspiration, the development of observational skills takes a huge leap forward.

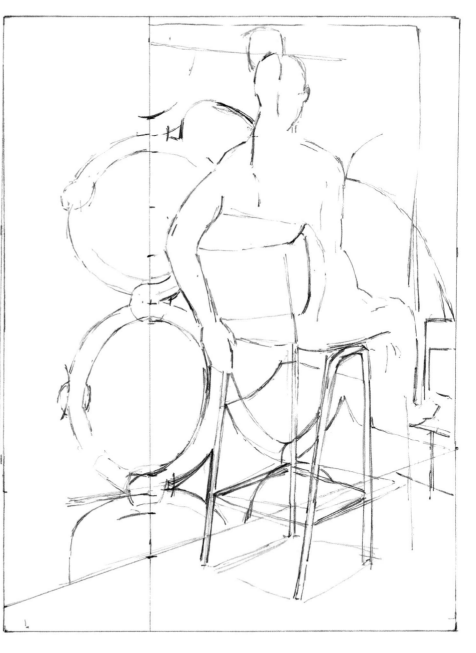

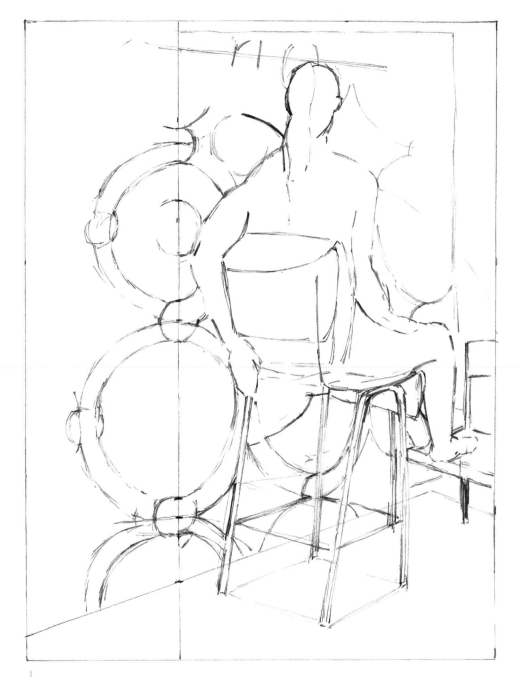

Notice how the meshing together of the pattern, chair and the figure help with the foreshortening of the receding arm and leg. Parts of the pattern sweep in and connect with the stool or echo shapes in the figure; all are useful in positioning elements of the drawing. The strong sense of connection between the figure and background stems from a more complete way of seeing; it is good to get away from the notion of subject and background and see the latter as being as important as the figure.

5 **The completed drawing** is a great success, intriguing in the way the figure is created as much by observing and drawing the space around her as by drawing her. The drawing also demonstrates the value of being aware of space and harnessing the power of negative shapes. As a result of this, the arm, legs and feet recede beautifully. From what seemed to be a very challenging set-up the student made one of those drawings that are real watersheds in an artist's journey – a real breakthrough drawing.

Techniques used

Line
Measuring
Negative shapes
Determining eye level
Perspective

Light and colour

Christelle in the Spring

In many parts of the world, the return of spring brings longer days and better light and perhaps some extra energy to put into making work. But wherever you live, certain times of year bring clear, strong light that gives clarity to the various hues you may perceive in a set-up, and particularly in flesh, making the process of working in colour far more pleasurable.

With a feeling of optimism, I had arranged for a model to come to pose for me on what turned out to be one of the first good days of the spring – perfect for a study in light and colour. I was going to have another try with pastels, a medium that I find difficult to work with but am determined to succeed at. Pastels are the perfect medium for studying light and particularly colour.

I selected an informal and comfortable reclining pose on a sofa; this relaxed atmosphere helped with the process of drawing. A clear, strong spring light coming in from the right bathed the set-up, heightening the contrast, and making the model appear monumental. The initial impression made by this light was of very solid, hard-edged forms bathed in light that swallowed up details.

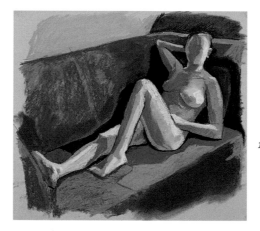

1 | **The first step was to draw out** the figure in simple terms using willow charcoal. Charcoal has the advantage of allowing constant reworking – alterations can be made by just rubbing the line in question away, so the drawing was kept fairly fluid and open-ended until the main elements were fixed in place. The first line described the overall direction of the body and ran along the outstretched leg up into the shoulder. This was followed by the centre line through the torso, which changed direction at the shoulders to describe the axis of the head. Next came lines marking the axes of the shoulders and breasts. Several more lines briefly described the sofa. With charcoal, unlike with other media, I am inclined to accept some looseness in the drawing, and in this case most of the early lines would be revised later. The charcoal took well to the lightly textured paper; for a moment I was tempted to make a tonal study in charcoal rather than face the test of pastel.

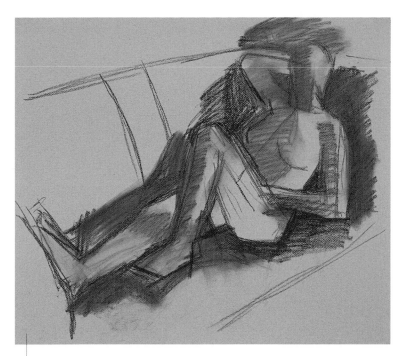

3 | *I am an avid mixer of colour* but with pastels you rely on pre-selected colours that often look different on the paper to their appearance in stick form. It took some time to select a tint of greenish raw umber that seemed to describe well much of the initial impression of the shadow areas. I also found a very pale tint of earth red that worked well for the highlights and an earthy violet for the mid-tones. To give more crispness and certainty to the edges, I turned to compressed charcoal but used it sparingly; very dark shades in pastel are rare and tend to be hard so I felt charcoal was my best strategy.

2 | *Using hard pastel* in a dark umber shade, I began to add solidity and structure to the figure, reaffirming elements of the initial drawing that I felt were correct. I then began to add tone with vigorous hatching, keeping the planes very hard-edged – I felt that a strong underdrawing would be a positive influence in rendering the very direct quality of the light. The hard edges can be seen on the upraised leg, where the front surface is described in a very flat manner with no transition into the side plane, on the upper part of the right arm and also on the head. Using a cloth I blended the shading and made it more continuous without losing the strength of the under drawing. At this stage I was considering how I might make the first colour statements in the drawing.

TIP

Before using your pastels, make a sample mark on paper and write down the number, name or reference of the pastel. When all that remains of your pastel is a small crumb, this information will help you to buy the correct tint and avoid duplication when shopping.

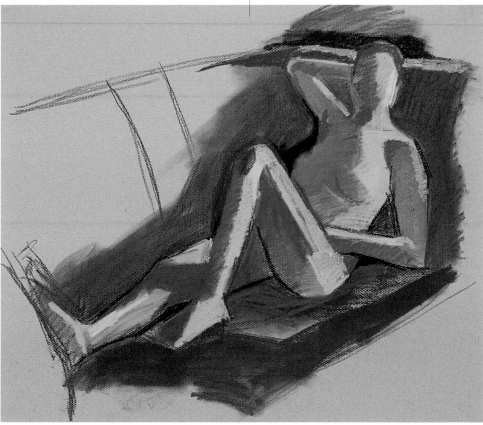

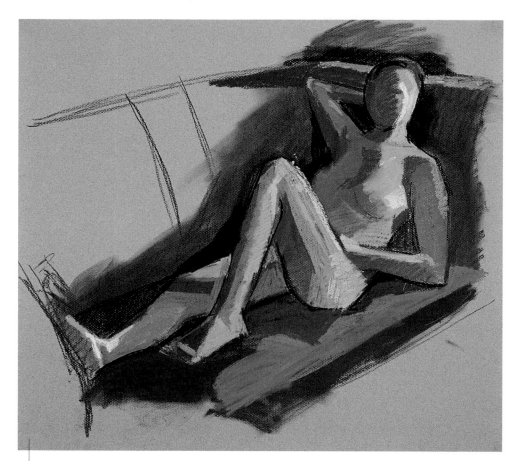

5 | **A strip of highlight** was added to the outstretched leg, the hip and the edge of the nearest breast. Using an earthy violet, I added a patch of reflected light to the furthest side of the face and to the distant shoulder. The raking light across the sofa near the feet was suggested by a warm red. By now I had found a useful handful of tints to keep in my hand.

4 | **After a break I realized** that parts of the drawing were not as accurate as they could be, particularly the head. Using compressed charcoal for its positive qualities I redrew the head, making it slightly larger and more rounded. The arm reaching behind the head was also redrawn, slightly lowering both it and the shoulder; and the upraised knee was moved backwards slightly. Looking into the highlight areas I sensed some patches were cooler than others such as the upraised leg and part of the nearest breast, and to these I applied a pale violet. Due to the scale of the drawing and the quality of light as it hit her body, I decided not to include the model's facial features, fingers or toes. If at some stage I could imply them subtly without losing the monumental quality, I would.

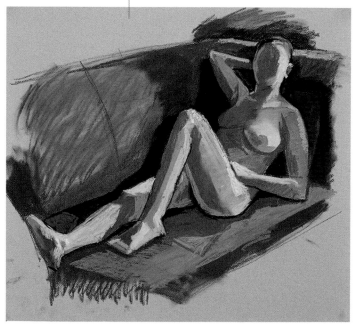

6 **With my model gone** there was still some work to do. The sofa and wall needed finishing, and without the pressure that often comes with one's obligation to the model, I was able to rework some areas of highlight based on memory of the pose. These areas had become too loaded with pigment so that colour was no longer gripping, so using a bristle oil-painting brush, I cleaned out the areas, allowing fresh colour to be applied.

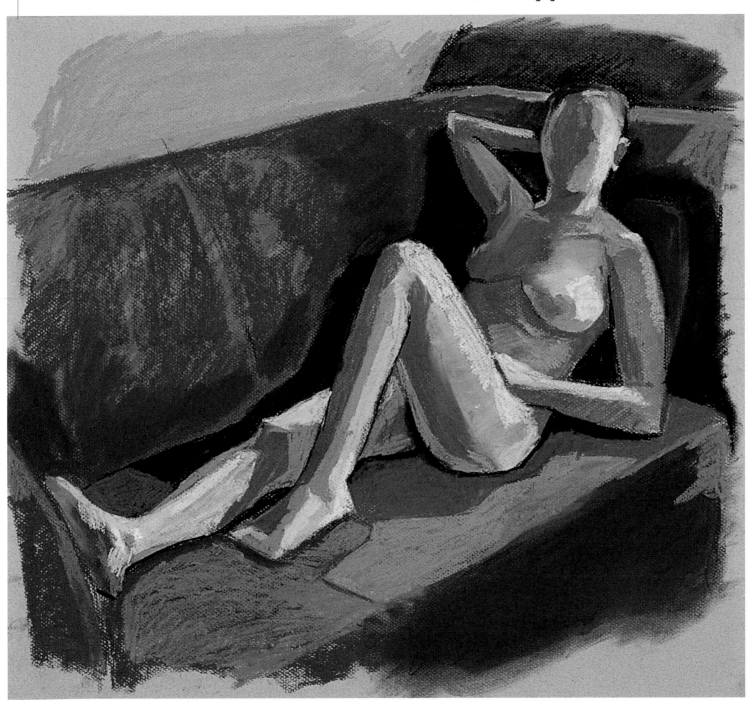

Glossary

Absorbency

The extent to which a paper will soak up paint, controlled by a gelatinous substance known as size.

Acid free

A term used to describe the neutral pH of materials, particularly papers, which signifies that the product will not degenerate over time due to the action of acidity.

Acrylic

A synthetic resin used in the preparation of binders in paints and inks.

Axis

An imaginary line running through a form, around which elements are placed.

Balance

The equilibrium achieved by the body that allows stability when adopting poses.

Binder

A binder envelops a pigment, protecting it from mechanical damage, allowing it to be spread out and acting as an adhesive that glues it to the chosen support. Gouache, watercolour and some inks use gum Arabic as their binder; shellac is a traditional binder for waterproof inks. Oil paint uses linseed oil as a binder.

Bistre

A traditional pigment made from beech tar that was a colouring agent in traditional inks.

Blind drawing

A drawing method in which the artist looks at the subject but not the drawing, encouraging scrutiny of the subject rather than recourse to preconceptions about it. This helps to train the eye and forges a strong link with the subject.
Also referred to as contour drawing.

Blocking in

The application of broad areas of paint that form the base of a painting, in which masses of light and dark shapes may be freely brushed to help establish a composition.

Body colour

An opaque form of watercolour and its accompanying techniques, such as gouache. Also the technique of working with opaque rather than transparent colours.

Chalk

A broad term that encompasses mark-making, white chalks and solid, natural forms of iron oxide.

Charcoal

After chalk, charcoal is the oldest form of drawing material. It is made by firing various types of wood in the absence of oxygen until it forms carbon. Willow is the commonest form of charcoal, but vine and beech are sometimes used.

Cockling

The term used to describe the buckling of unstretched papers when they become saturated with water. This is more of a problem with papers below 300gsm.

Cold-pressed paper

Paper that has been manufactured through rollers at a cool temperature. Its surface is less smooth than that of hot-pressed paper but smoother than the surface of rough paper. It is also known as 'not' paper, literally meaning 'not hot pressed'. It is sometimes referred to as 'Fin'.

Coloured neutral

A subtle, unsaturated colour, produced by mixing a primary and secondary colour in unequal amounts.

Complementary colours

Complementary colours are directly opposite each other on the colour wheel. Examples include red and green, blue and orange, and yellow and violet. The complementary of a primary is a mixture of the other two primaries. Complementaries have a neutralizing effect on each other when mixed and clash when placed side by side.

Composition

The organization of the elements of a drawing to create a coherent and well-resolved whole. A successfully composed drawing should not only depict the subject effectively but also work well in abstract terms.

Compressed charcoal

A dense drawing material made from black pigment combined with a binder, which is well suited to creating tonal drawings.

Conté

A proprietary brand of crayon formed from pigment combined with a weak binder, which has a relatively chalky quality. The name conté is often used as a generic term for similar products made by other manufacturers.

Crayon

A drawing material in stick form, examples of which include pastels, coloured crayons and conté crayons.

Cross-hatching

A second layer of hatching applied at a different angle to the first, which increases the tonal range of the drawing.

Further layers may be applied, each increasing the depth of tone.

Drawing

The act of mark-making using a drawing tool or material across a support for the purpose of making a representation or pattern. Most drawing materials deposit their pigment in the texture of the paper.

Dye

A colouring agent used primarily in inks that is generally fugitive (has poor resistance to light). Dyes may be of vegetable or synthetic origin.

Earth colours

A range of natural pigments obtained from the ground, made from clays, iron oxides and other minerals. Examples include raw sienna, yellow ochre and raw umber.

Eye level

An imaginary horizontal line that coincides with the height from which you view objects and space while drawing; an awareness of this level aids understanding of perspective.

Ferrule

The tapered, cylindrical metal collar that fits around a brush handle and holds the brush hairs in place.

Fixative

A form of weak varnish that fixes loose pigment particles to the support, preventing their transference to other surfaces and subsequent loss of the drawing.

Foreshortening

The distortion of form when the object or person is viewed at an angle to the picture plane.

Format

The shape or dimension of the given image on the support.

Fugitive

The term used to describe pigments or dyes that have poor fade resistance to light.

Glaze

A transparent passage of colour that modifies the previous layer of colour or under drawing without obliterating it.

Gouache

A form of water-soluble paint characterized by its opacity, which is traditionally bound in gum arabic. The opacity of gouache allows constant reworking of the image to keep track with movement and changes in light. It is often referred to as body colour.

Graphite

A natural form of carbon and the raw material of the pencil.

GSM

The unit of grams per square metre (GSM) used to indicate the weights of papers.

Gum

The water-soluble secretion obtained from the sap of various trees, such as gum Arabic from the acacia tree, that is used as adhesives and binders.

Hatching

A form of shading that employs repeated lines, which may be straight or curved, for the purpose of adding tone or volume to a drawing.

Highlight

An area of a drawing or painting that has the highest tonal value (the lightest tone).

Hot-pressed paper

A very smooth paper made by being pressed through hot rollers during its manufacture. The combination of pressure and friction produces the smooth surface. The abbreviation H.P. or the term satiné is often given to this surface. Hot-pressed papers are particularly good for pen-and-ink, pencil and silverpoint.

Horizon line

A line coinciding with the artist's eye level to which lines rise or fall under the effects of perspective.

Ink

A liquid form of drawing material used with pen or brush that dries to form water soluble or water-resistant films.

Iron gall

A traditional ink made from the galls of the oak tree that is characterized by its initial blue-black hue.

Ingres paper

Generic name given to several brands of textured drawing paper available in many tints and favoured by pastellists. The texture grips the particles of the softer drawing materials, such as charcoal and crayon, helping to create a rich laying down of tone.

Life drawing

The act of making a drawn representation directly from the figure as opposed to working from casts or photographs.

Light-fastness

The degree of fade resistance applied to drawing and painting materials.

Linear description

The means of making drawings by relying on line alone, without introducing any form of shading. This is the most elementary and natural way of drawing.

Local colour

The specific hue and tone within a given area of the subject. The pigmentation of the lips, pupils and hair of a model are examples of areas where local colour may be observed. When trying to convey the form of the figure, local colours should be overlooked.

Measurement

A means of gauging the scale and proportion of different parts of the body and of elements of the picture space. This can be achieved by selecting a unit of measurement against which distances may be compared; this unit is very often the head. Sight-sizing drawings and reading measurements against a scale such as a ruler are alternative methods.

Mineral

Non-organic matter that is used to make some of the most permanent pigments, including many of the earth pigments that are naturally occurring forms of iron oxide and also refined minerals such as cadmium and cobalt.

Negative shapes

Enclosed shapes or spaces between forms or objects that greatly assist in the construction of pictorial space and achieving foreshortening. These can be viewed as positive abstract shapes in a composition.

Neutral colour

A colour created by mixing unequal amounts of complementary colours, which cancel out to form a dull, neutral colour.

Optical mixing

A technique in which colours are placed on a support so as to react with each other, rather than mixing them in a palette. Optically mixed colours are most effectively perceived when viewed from a distance so that they appear to the eye as a single colour. Optical mixing is often employed in pastel work in the form of hatching and cross-hatching to create gradations of colour.

Outline

A line that describes the exterior shape of an object or form and is the most direct means of depiction.

Palette

A portable surface on which colours are mixed prior to application. Also a particular range of colours selected by the artist.

Paper size and weight

Papers can be found in a number of formats, The most popular is the universal 'A' size system. The following sizes are convenient for life drawing:

A1	594 x 841mm	(23.4 x 33.1 in)
A2	420 x 594mm	(16.5 x 23.4 in)
A3	297 x 420mm	(11.7 x 16.5 in)
A4	210 x 297mm	(8.3 x 11.7 in)
A5	148 x 210mm	(5.8 x 8.3 in)

Pastel

A saturated artists' colour in stick form, which, although dry, is officially classed as a paint.

pH

The degree of acidity or alkalinity of a material is expressed by its pH number; pH7 is neutral. Selecting paper with a neutral pH will ensure that it does not suffer degradation over time.

Perspective

A visual phenomenon that causes objects to appear smaller as they recede and parallel lines to converge to vanishing points on the horizon. Employing perspective is a means of depicting the three-dimensional world on a flat surface.

Picture plane

An imaginary plane that coincides with that of the picture.

Picture space

The space alluded to in drawings behind the surface of the picture plane.

Pigment

A colouring agent that forms the basis of all permanent artists' materials.

Portfolio

A rigid folder used for the storage and transportation of works of art.

Precipitated chalk

A white filler used as an extender for creating tints when making soft pastels.

Primary colours

These are the three colours – red, yellow and blue – that cannot be made by mixing other colours. In various combinations they form the basis of all other colours.

Props

Items of furniture or objects that enhance or give a sense of narrative to the set-up.

Quattrocento

The name given to the period 1400–1500; the early period of the Italian Renaissance.

Quill brush

A traditional brush made using a bird quill for a ferrule, which is suited to flowing, flexible lines.

Reductive drawing

A drawing method based on erasing the drawing material from the surface of the support. This method is particularly suited to the study of light.

Reserving

The practice of leaving areas of the paper bare when applying watercolour washes, allowing these areas to serve as highlights in the completed painting.

Restricted palette

A palette that aims to use a minimal range of useful colours in order to give simplicity to colour mixtures. This helps to ensure that different areas of the drawing or painting relate well to each other and achieve colour harmony.

Rough

A term used to describe heavily textured surfaces of paper; the name Torchon is an alternative name. These are generally hand-made papers that have not been treated by pressing.

Sanguine

A solid form of natural earth with high clay content, sanguine has a long history in drawing and was used by early Renaissance artists such as Raphael and Leonardo Da Vinci.

Sepia

A traditional colouring agent for inks that is procured from the dried-out, inky secretion of the Adriatic cuttlefish.

Shading

The method of introducing shade (tone) to a drawing to describe the fall of light and shadow upon a subject, helping to convey its three-dimensional form.

Shellac

A resin that is obtained from the branches of several species of tree in India. It is deposited by insects that feed on the tree's sap.

Sight size

A scale of drawing in which measurements taken at arm's length are transferred directly to the paper. It is an efficient way of determining the relative proportions of the body and of the set-up, and allows rapid progress of the drawing.

Silverpoint

The use of a metallic drawing tool that reacts chemically with the support on to which it is drawn to make its mark.

Space

The illusionary space created on the surface of the paper and lying behind the picture plane.

Spatial relationships

The relationship between objects in space as opposed to the distance between them on the flat surface of the support.

Stump

A tool made from tightly rolled paper that is used for blending a range of materials, such as pastel and charcoal.

Support

The surface upon which the drawing or painting is carried out, such as paper.

Tint

Any colour mixed with white.

Tonal values

Tonal values are the various intervals between light and dark that are used in drawing and painting to convey the influence of light.

Tone

The degree of light or dark seen on any solid object under the influence of light.

Ultramarine

A violet-blue pigment that is a core colour in most palettes. It was originally made from lapis lazuli.

Under drawing

The first establishing marks of a drawing or painting to aid the subsequent placement of key elements.

Unit of measurement

A distance against which other elements of the body or picture space are compared in order to gauge scale.

Vanishing point

The point towards which parallel lines appear to converge under the effects of perspective.

Viewfinder

A device that can be used for measurement and composition. A basic version consists of two L-shaped cards joined together in such a way that their aperture can be altered in size. The rectangular borders of the aperture help to crop out unnecessary elements of the scene during composition. More sophisticated and convenient acetate, gridded versions can be used for measurement as well as composition.

Wash

A layer of thinly applied diluted colour.

Watercolour

A water-soluble form of paint that uses natural gums as a binder. Watercolours are generally transparent.

A

Achilles tendon 50, 51
acid-free papers 26, 36, 106
acrylic ink 31
adductor magnus 50, 51
aerosol 40
Altamira, Spain 7
ammonium carbonate 43
arms 96–97
auditary hiatus 48–49
axis
 features 91
 limbs 96, 97
 on head 90
 torso 94, 95

B

balance 101–102
barium sulphate 34
Belvedere Torso 8
biceps 50, 51
biceps femuris 50, 51
binders 24, 26, 30
bistre 31
blanc fix 34
blind drawing 72–73
Bonnard, Pierre 10
brachioradialis 50, 51
breast bone, see sternum
brushes 40
burnt sienna 22

C

carbon 16
cartridge paper 36
cave drawings 7
Cézanne, Paul 10
chalk 22–23
charcoal 20–21
 and form 54, 55
 compressed 20, 21
 oil 21
 shading 64
 willow 20, 21
chiastic pose 7
Chinese brush 40
Chinese ink 31

Chinese stick ink 26
clavicles
 and balance 102–103
 as landmarks 86
 feature of torso 94–95
 location 46, 47
cockling 36
cold-pressed paper 36
collar bones, see clavicles
colour wheel 67
comparative measurement 84–7
 and foreshortening 82
complementary colours 67
composition 74–75
compressed charcoal 20, 21
 reductive drawing 65
 shading 64
conté 22–23
 shading 64
Conté, Nicolas-Jacques 16
context 76–77
coordination, hand and eye 72–73
coronal suture 49
cotton-rag paper 36, 37
cranium 48
crayons 23, 24–25
cross-hatching 27, 63
cuttlefish 43

D

daylight bulb 12
Degas, Edgar 10
 After the bath, woman drying her hair 11
 After the bath, woman drying herself 11
deltoid 50, 51
Doryphoros 7
drawing board 39
Dürer, Albrecht 8

E

easel
 in home studio 13

radial 13, 38
 extending 38
erasers 40
erasing techniques 65
extending easel 38
external oblique 50, 51
eye level 78, 80, 81
eye sockets, see orbits

F

features 90–93
feet 98–99
femur 46, 47
fibula 46, 47
figure
 context of 76–77
placing in composition 74–75
fingers 98–99
fixative 41, 107
flexor carpi radialis 50, 51
flexor carpi ulnaris 50, 51
forearm 46
foreshortening 82–83, 110–113
 and perspective 80, 81
 limbs 96–97
 proportion 52
form 54–55
format 74
Freud, Lucian 11
frontal bone 48

G

gastrocnemius 50, 51
gluteus maximus 50, 51
Gogh, Vincent van 10
gouache 34–35
gracilis 50, 51
graphite 16–17
 reductive drawing 65
Greek classicism 7–8
gum 30, 32, 35, 42, 43
gum Tragacanth 42
gum strip 36

H

hands 98–99
hatching
 and form 54, 55

method of shading 63, 65
 pastels 26
head, drawing 90–93
 axes 90
 ears 92–93
 eyes 92–93
 lips 92–93
 nose 92–93
heating 12, 13
highlight 88, 89
Hockney, David 11
Holbein, Hans 19
homemade materials 42–43
home studio 12–13
horizon line 80
hot-pressed paper 36, 43
humerus 46, 47

I

iliac crest 46, 47
Indian ink 31
India rubber 40, 65
Ingres, Jean-Auguste-Dominique 9
 Study for the Turkish bath 10
Ingres paper 37
ink 28, 29, 30–32
iron-gall ink 31
 recipe 43
iron oxides 22
iron sulphate 43

J

John, Augustus 10

K

kneadable eraser 40, 65
kneecap, see patella
Kitaj, R. B. 11

L

Lake District, England 16
landmarks (on body) 86
Lascaux, France 7
latissimus dorsi 50, 51
Lecoq de Boisbaudran, Horace 10
legs 96–97
Leonardo da Vinci 8, 19, 22, 30
 Drawing of a man's shoulder

and lower body 8
light 100–101, 122, 123, 124, 125, 134, 135, 136, 137
lighting 12, 13
 anglepoise lamps 12
 clip-on lamps 12, 13
 daylight bulb 12
limbs 96–97
linear description 61
line drawing 58–61
 and form 54, 55
lower jaw, *see* mandible

M
mandible 48, 49
Manet, Edouard 10
manganese black 22
materials 16–43
Matisse, Henri 10
maxilla 48, 49
maxillary bones 48
measurement 84–87
 and foreshortening 82, 83
 comparative 82, 84–87
 sight-sizing 83, 84–87
Michelangelo 8
movement 104–105
muscles 50–51

N
nasal bone 48, 49
negative shapes 110, 111, 119, 120, 121, 130, 131
 and picture space 78, 79
 foreshortening 82, 83
nibs
 conveying form 55
 effects 28-9
 types 28–29

O
oak-gall ink, *see* iron-gall ink
optical mixing
 coloured crayons 24, 25
 pastels 26, 27
occipital bone 48
occipital protuberance 48–49

orbits 48, 49
over-washing 23, 24, 25, 27

P
paint formats 32
palette
 conté 69
 enamelled 41
 gouache 68
 mixing 66–69
 pastel 69
 plastic 41
 watercolour 33, 69
papers 34–35
parietal bone 48, 49
pastels 26–27
patella 46, 47
pectoralis major 50, 51
pelvis
 anatomy 46, 47
 and balance 102, 103
pencils 16–17
 clutch 17
 hardness 17
 sharpening 17
pen and ink 55
pens 28–29
perspective 80–81
 and picture plane 76, 77
pH 36
Picasso, Pablo 10
picture plane 78, 130
picture space 78–79
pigments
 and paper 36, 37
 chalks 22
 charcoal 21
 conté 22
 crayons 24
 found materials 22
 gouache 34
 homemade materials 42–43
 ink 30
 pastels 26
 silverpoint 19
 watercolour 32
Pissaro, Camille 10

plastic erasers 40
Polykleitos 7
portfolio 39, 106
precipitated chalk 42
primary colours
 colour wheel 66–69
 gouache 68
 watercolour 32, 33
proportions (of body) 52–53
 foreshortening 82, 83
props
 context 76, 77
 in home studio 12, 13

Q
quill brush 40

R
radial easel 38
radius 46, 47
Raphael 8, 22
rapid drawing 72, 73
rectus femuris 50, 51
red ochre 22
rectus abdominus 50, 51
reductive drawing 89, 100
 techniques 65
Rembrandt 9, 30
Renaissance, the 8
Renoir, Pierre-Auguste 10
reserving 114, 115, 122–125
restricted palette 66–69, 114–117
ribcage 46, 47
Rodin, Auguste 10
rough 37
Rubens, Peter Paul 9, 30
 Anatomical study of a male 9
rulers 87

S
sable brush 40
sacrum 46, 47
sagittal suture 48, 49
sanguine 22, 23
sartorius 50, 51
scapulas 46, 47
Schiele, Egon 10

scumbling 35
semi-blind drawing 73
semimembranosus 50, 51
sepia ink 30, 31
 recipe 43
 tone 89
Seurat, Georges 10
shading 62–65
 and form 54, 55
shading materials 64
sharpening block 40
shellac 30, 31
shoulder blades, *see* scapulas
sight-sized measurement 84–87
 and foreshortening 82, 83
silverpoint 18, 19
 paper 43
skeleton 46–47
skull 48–49
smudging
 and form 54
 pastels 27
 pencil 64
soleus 50, 51
space
 and sight-sizing 12
 in studio 12, 13
 working with 78–79
spatial relationships 78, 79
spine
 anatomy 46, 47
 axis of body 94, 95
spray-diffuser 40
Sri Lanka 16
sternum 46, 47
storage
 home studio 12, 13
 of work 106–107
sutures 48, 49

T
techniques 58–69
templates, erasing 65
temporal bone 48, 49
tibia 46, 47
tibialis anterior 50, 51
Titian 8
Tiziano paper 37

tonal drawings 54
tonal values 88, 89
tones 88–89
 premixing 88
 reductive 89
 sepia 89
tools 16–43
torso 94–95
trapezius 50, 51
triceps 50, 51

U
Uglow, Euan 11
ulna 46, 47
upper jaw, *see* maxilla

V
vanishing point 80–81
vastus laterali 50, 51
vastus medialis 50, 51
Venus de Milo 8
vertebral column 46, 47
viewfinders
 for composition 74
 functions 74, 75
 making 41
 measuring with 74, 82, 87
volume (of body) 54, 55

W
washes 32, 34, 114–117, 122–125
watercolour 32–33, 114–117, 122–125
willow charcoal 20, 21

Y
yellow ochre 22

Z
zygomatic arch 48, 49
zygomatic bone 48

Author's Acknowledgements

This book is respectfully dedicated to the memory of Norman Blamey, a great draughtsman, teacher and remarkable individual, and to students past and present.

The author would like to thank Anna Cheifetz and the team at Cassell Illustrated, John Conway and Fiona Screen at Essential Works, Paul Docherty for his hard work in making the text work and Penny Stock for designing the book so well.

Thanks also to my wife Claire and daughter Hannah for their patience, and to the following for their support and encouragement:
At Heatherleys School of Fine Art:
John Walton, Susan Engledow, Tony Mott, Veronica Ricks, Richard Thorneycroft, Mary Volk.
At The Slade School of Fine Art:
Professor John Aiken, Jo Volley, Sandra Smith.
At West Dean College:
Robert Pulley
Dr Edward Winters

Finally thanks to the models, those unsung heroes, who have worked with me during the project:
Emmanuel Creplet, Claire Morley, Christelle Pardo, Oleya Pardo.

Picture credits

All illustrations by Ian Rowlands apart from: page 105 (left) Natalie Gulliver; pages 105 (bottom right) and 130–133 Anthony Pendlebury; pages 118–121 Daniel Preece.
All images featured in the Introduction appear courtesy of Corbis:
page 7 Vatican Museum; page 8 Alinari Archives/CORBIS; page 9 Christie's Images/CORBIS; page 10 Francis G. Mayer/CORBIS; page 11 (top) Kimbell Art Museum/CORBIS , (bottom) Christie's Images/CORBIS.

Essential Works

Series development, editorial, design and layout by Essential Works Ltd., London
Project Designer Penny Stock
Project Editor Paul Docherty